MW00339605

The Campus History Series

DRURY UNIVERSITY

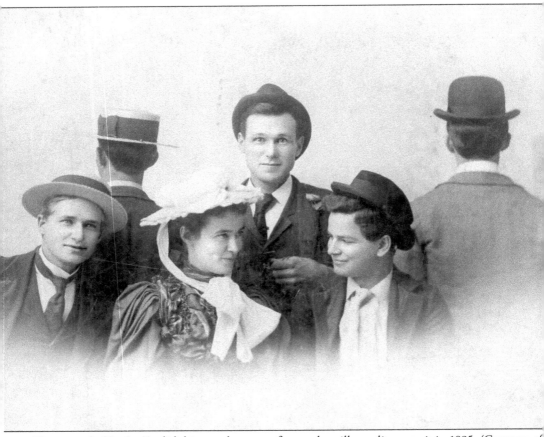

HAMMING IT UP. An English history class poses for a rather silly studio portrait in 1895. (Courtesy of Drury University and Drury University Archives.)

ON THE FRONT COVER: A group of faculty, students, and staff poses on the front steps of Fairbanks Hall about 1885. (Courtesy of Drury University and Drury University Archives.)

ON THE BACK COVER: A contemporary aerial view shows the Drury University campus. (Courtesy of Drury University and Drury University Archives.)

The Campus History Series

DRURY UNIVERSITY

WILLIAM GARVIN

ARCADIA
PUBLISHING

Published by Arcadia Publishing
Charleston, South Carolina

Printed in the United States of America

Library of Congress Control Number: 2023934293

For all general information, please contact Arcadia Publishing:
Telephone 843-853-2070
Fax 843-853-0044
E-mail sales@arcadiapublishing.com

Visit us on the Internet at www.arcadiapublishing.com

For Leaugeay Phillips Weber
Dearest friend, now departed

CONTENTS

ACKNOWLEDGMENTS

It is often said that one does not work in an academic environment for its remunerative rewards. While that may be true to at least some extent, heartfelt thanks are due to Drury University for making this project possible. In particular, Aaron Jones and his finely honed sense of "Druriosity" has shared my interest in the history of Drury for over 30 years. Former presidents John Moore and Todd Parnell must be thanked for their support and keen, articulate historical perspectives that they have always been willing to share. Former student and Vice Pres. Jim Buchholz, now no longer with us, was one of the best keepers of this school's history and ethos. There are close colleagues, too, who have supported me in a number of ways as I have worked on this project. Thanks are due to my fellow librarians at Drury's F.W. Olin Library: Holli Henslee, Katherine Bohnenkamper, and particularly Phyllis Holzenberg and Jacqueline Tygart. Jill Holmes and Christie Garrison in Drury's business office have provided support not just on this project but also on much of the day-to-day financial questions that baffle someone more suited to the realm of literature and history. Sarah Jones, in Marketing and Communications, gave critical assistance and advice in tracking down a number of images, and I often borrowed her artist's eye on questions of image choice and layout. Thanks are due to my editor Stacia Bannerman and acquisitions editor Lindsey Givens at Arcadia Publishing. I owe particular thanks to my faculty colleagues Scott Simmons, Chris Branton, Jo Van Arkel, and particularly Chris Panza for their friendship, encouragement, and support in this work and many other matters. Above all, thanks to my family, Crista and Sam, for their patience and support.

I have striven to make this brief account of Drury University's history as accurate and engaging as I can. There are numerous people, events, and aspects of this community that might have been included but were not due to my own judgments and choices. In the course of my research for this book, I discovered several inaccuracies and misconceptions (held not only by others but also by me) in the historical record. I have tried to correct these as best as I could. As in all histories, too, there are sometimes competing—and very different—narratives describing particular events, people, or objects. In such scenarios, I have tried to render what I thought the likeliest interpretation. That being said, any errors or oversights are mine and mine alone.

Unless otherwise noted, all images are courtesy of Drury University and Drury University Archives.

INTRODUCTION

When Drury College opened its doors on September 25, 1873, its prospects for the future looked bleak. That day, at 1:30 in the afternoon, Nathan Jackson Morrison, the first president of Drury College, stood in the second-floor window of the college's first building and rang a dinner bell to summon students to the institution's first day of classes. As Morrison would later recall, some of the students hesitated as they entered the building: they stopped in indecision at the front steps and peered in through the door. Their hesitation was not unjustified. The building they were entering had been thrown up in about eight weeks and was not even finished: the 39 students who enrolled that day, along with the six members of the faculty, had to share the building with carpenters. Not all of the furniture had been set up, the plaster was hardly dry, and the baseboards and window casements had not yet been put into place. A lien had been placed on the building by a nasty attorney who was making public threats to "wipe out the whole concern." President Morrison had even had to borrow the dinner bell from a local boardinghouse.

The campus that would later be nicknamed "the Forty Acres" was on that day only a couple of acres and in its undeveloped state was not a very remarkable piece of real estate. One contemporary described the land as "partly prairie and partly overgrown with scrub oak and sumac." Another recalled a rough landscape of thick hazel brush, oak and hickory saplings, and a cornfield to the north of the campus. For many years, the faculty and staff had to assemble a week or so before classes started in the fall, take a firepot, shovel, or burlap bag, and burn off the summer growth on the campus to prepare the grounds for the arrival of students. No one was excused from this choking chore: even the dean and president had to brave the smoke and do their bit.

The social and economic terrain of the period was just as wild, and it was probably not the best moment to undertake the foundation of a college or any other institution. Though the Civil War had ended eight years earlier, it continued to be the source of much hardship and bitterness, and the physical vestiges of that conflict—a Union trench line—still scarred the college grounds. (The remnants of those earthworks can be seen on campus to this day, on the east side of Burnham Hall.) The college founders—mainly New England Congregationalists who had been staunch abolitionists—had to take care not to inflame the lingering resentments that were still fresh in their adopted community. Beyond Springfield, not very far to the west, much of the territory was still frontier, and among the first students that day were seven Native American students, predominantly Choctaws, whose forebears had been forcibly relocated from the east to the Indian Territory, or "IT" as it was often called. The Panic of 1873, one in a long line of national financial crises, had hit the farming communities of the Midwest particularly hard. President Morrison had spent the preceding months scouring the local community for "subscriptions," or donations and pledges, to fund the nascent school. By the time the panic had set in, about half of the pledged donations had been withdrawn by financially embarrassed subscribers.

Of the 39 students in attendance that day, none were actually college students. The reality of the situation was that every student was enrolled in the Drury Academy, which was essentially a secondary school that had to be set up to prepare students for the rigors of college-level academic studies. So, at least for that moment, Drury College was operating as a college that had no college students. Indeed, the college would have no college students until the following year and would not matriculate a class of college students until the spring of 1875, when five students, all women, would graduate with college degrees.

The years that followed were often marked by hardship and, as in any human undertaking, personal squabbles and disagreements among key players. In a few instances, there were even periods of existential threat: at one point early on in its history, the finances of the college fell into such straits that faculty and staff could not be paid for several months. Devastating fires, two world wars, two pandemics, a variety of social, national, and institutional upheavals, financial panics, recessions, and the Great Depression would challenge the college over the next century and a half. But Drury College, which would become Drury University in 2000, would not only continue to grow but would prosper. The enterprise, launched with the ringing of a borrowed boardinghouse dinner bell, endured.

Today, on the cusp of its 150th anniversary, Drury University sits on a campus of about 90 acres and more than 50 buildings. An institution that originally offered four programs of study now provides over 60 bachelor's degree programs, nine graduate degree programs, plus numerous associate degrees, minors, certificates, and credentialing pathways. The original faculty cadre of six now comprises over 100 full-time faculty members and over 100 part-time and adjunct faculty. From the rather timid and tentative establishment of a baseball club in 1886, Drury athletics now boasts 19 NCAA Division II teams and 12 club sport teams. And since 1875, more than 41,000 students have received degrees from Drury, and the institution now has over 30,000 living alumni.

Statistics of growth and longevity only tell part of the story, of course. We all sometimes have an understandable tendency to think of institutions of higher education (particularly those with which we have no ties) as physical entities, as plots of land that contain a collection of stately buildings and expansive green spaces, or perhaps as enterprises that offer some sort of sanctioned credential, or maybe as organizations whose health and stature might be gauged by metrics like enrollment numbers or a robust endowment portfolio. Ultimately, though, the character of a college or university is molded and perpetuated by a collection of people, by a diverse community of learners who understand that they carry a special legacy that goes far beyond buildings and grounds or statistical measures. It is a legacy that cannot always be articulated—it is a spirit, a sort of kinship, with those who have come before us. Former president John Moore used to speak of this spirt as the "historic weight of the institution." If you are part of the Drury community, I hope that many of these images will make you feel the wonderful historic weight of this place, your institution.

One

BEGINNINGS

"ON THE GROUND WHERE THEY ARE NEEDED": THE IDEA IS BORN. Drury College was the creation of 14 churches known as the Springfield Association of Congregational Churches of South West Missouri. In the association's record book, in an entry dated March 23, 1872, the following resolution is recorded:

> Whereas the rapid increase of population in the South West urgently calls for a large increase of Pastors, Teachers, & thoroughly educated men in every Calling, and—
> Whereas we believe that this want can be most practically and economically supplied by educating them on the ground where they are needed—
> Therefore—Resolved: that a committee of three be appointed to consider the best means for Establishing & the proper place for locating a College within the limits of this Association.

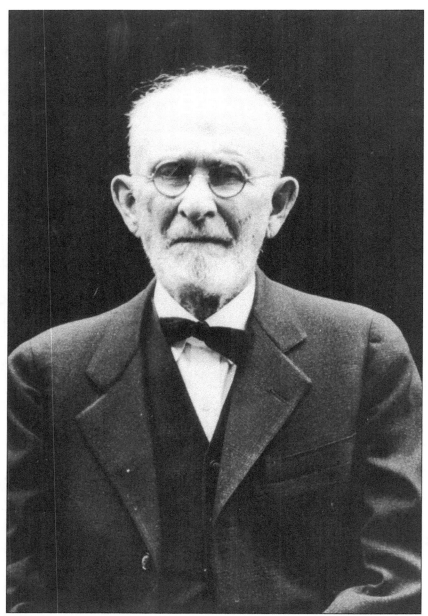

FOUNDER: CHARLES EDWARD HARWOOD. There is probably no figure in Drury's history who had such a marked influence on the institution as Charles Harwood. Born in Bennington, Vermont, in 1830, Harwood attended Williams College and initially practiced law in Wisconsin. In 1867, he moved to Springfield, where he worked as a land speculator, particularly in association with the Atlantic & Pacific Railroad. He was instrumental in the drive to locate Drury College in Springfield, made a large initial pledge for the project, used his influence to convince others to support the school, and was one of the first trustees for the college. As the infant college struggled in its early years, it was often Charles Harwood who came to its financial rescue. He would later serve as the vice president of an early petroleum conglomerate known as the Mexican Petroleum Company. Harwood died in California in 1933 at the age of 102, having served on the Drury Board of Trustees for almost six decades.

FOUNDER: JAMES HASWELL HARWOOD. The younger brother of Charles Harwood, James Harwood was born in 1837 in Vermont. He received a degree from Williams College and afterward graduated from Union Theological Seminary. He pastored several churches in Illinois but eventually followed his brother to Missouri, settling in Springfield in 1868. There, the following year, he was instrumental in founding the First Congregational Church of Springfield, was its first pastor, and became a circuit pastor for a number of other churches in southwest Missouri. He was instrumental in the founding of Drury; indeed, one history claims that the institution "was born in the mind of James H. Harwood." It was James Harwood, too, who raised most of the necessary subscriptions to fund the project: virtually on his own, he raised $50,000 in Missouri and another $100,000 in New England. Once Drury was founded, though, James Harwood was not directly involved in the operations of the college, due, perhaps, to disagreements he and his brother had with Drury's first president, Nathan Morrison. James Harwood died in California in 1932 at the age of 95.

FOUNDER: NATHAN JACKSON MORRISON. Nathan Morrison, Drury's first president, was born in New Hampshire in 1828, graduated from Dartmouth in 1853, and held both doctorate of divinity and doctorate of law degrees. He was named president of Olivet College in 1865, and after resigning that position in 1872, was named president of Drury in 1873, a position he held until 1888. While Morrison was a capable leader, he had a reputation as a difficult person. He himself admitted to being an autocrat but justified this by saying that in a young and "struggling" institution, "somebody must take the risks and consequently have the authority to decide and command. And this means . . . unity of counsel in one mind." He almost immediately clashed with the Harwoods, particularly James. As one contemporary put it, both men were "impatient of any opposition, and determined to have their own way," which meant that "the young school had two nurses whose natural jealousy was not always conducive to the best interest of the child." After leaving Drury, Morrison became the president of what would become Wichita State University, where he served until his death in 1907.

THE WOMAN WITH THE HALF VOTE: CORINNA ALLEN. On March 4, 1873, the Springfield Association of Congregational Churches met to decide where the new college would be located. A number of towns and cities had been suggested, but eventually the choice came down between Springfield or Neosho. The vote that followed was four and a half votes to four in favor of Springfield. The half vote was cast by Corinna Allen, a delegate from the Pierce City Congregational Church. While some have posited that Allen was only allowed a half vote because she was a woman, in reality it was due to a procedural decision. Each of the churches attending the meeting was given a single vote. The Pierce City church had sent two delegates: Allen and a Mr. Skews. Because there were two delegates, each was given half a vote. When the time to vote came, Allen cast her half vote in favor of Springfield, and Skews abstained. While Allen never shared the reasoning behind her "peculiarly decisive" vote, one observer speculated that it might have been due to "the promptings of a Christian motive." (Courtesy of the First Congregational UCC Church of Pierce City, Missouri.)

SPRINGFIELD COLLEGE.

THE First Term of the Springfield College will commence on

THURSDAY, SEPT., 25th, 1873,

AND CONTINUE TILL HOLIDAYS.

Equal Advantages to both Ladies and Gentlemen. Able and experienced Corps of Instructors.

The College will include two departments:— The Preparatory, and College proper—and will embrace four courses of study, viz: the Classical, Scientific, Ladies and Normal.

Special attention will be given in the Normal class to persons preparing themselves for Teachers.

Further announcement may be expected soon. For particulars address—

REV. N. J. MORRISON, D. D.

Springfield, Mo., July 31, 1873. President.

—46ltf

SPRINGFIELD COLLEGE. The project that would become Drury College was originally conceived and promoted as Springfield College. (It should be noted that several short-lived "colleges" that operated in the Springfield area before the Civil War were actually high school academies.) Paul Roulet, an early faculty member and chronicler of Drury's history, kept very comprehensive scrapbooks of newspaper clippings and other materials related to that history. (Three of Roulet's scrapbooks survive and are housed in Drury's archival collection.) This advertisement is the first item in the first scrapbook; the clipping was published in the *Missouri Weekly Patriot* on July 31, 1873. A later notation in Roulet's handwriting, dated June 13, 1874, indicates that "This is probably the first announcement of Drury College ever published." Particular prominence is given to the declaration that the school provided "Equal Advantages to both Ladies and Gentlemen."

FOUNDER: SAMUEL FLETCHER DRURY. Like the other founders of the college, Samuel Fletcher Drury was a New Englander. Born in Spencer, Massachusetts, in 1816, he spent his early years in that state. At the age of 22, though, he moved to Otsego, Michigan, where he set up a successful dry goods store. In Otsego, he was instrumental in founding a home missionary Congregational church for that community. It was his work with this church that eventually led to his involvement with the Olivet Institute, a college in Olivet, Michigan, that had been founded by a group from Oberlin College. Drury eventually became the chief fundraiser for what was by then Olivet College. It was through Olivet College that Drury met Nathan Jackson Morrison, who was Olivet's president from 1860 until 1872. When Morrison became president of what was then Springfield College, he persuaded Drury to pledge $25,000 toward the project. In recognition of his gift, the institution was named in honor of Drury's only child, Albert Fletcher Drury, who had died as a young man while attending Olivet College. Samuel Drury died in 1883.

DRURY COLLEGE. The renaming of Springfield College to Drury College took place only about a month before the institution opened its doors for its first day of classes. The second item in Paul Roulet's first scrapbook is this clipping, published in the *Missouri Weekly Patriot* on August 28, 1873. The text in the body of this advertisement is identical to the earlier notice—even the announcement date of July 31, 1873, has been retained, along with the repeated assurance that "Further announcements may be expected soon." The name of the college has been changed, of course, although it is interesting to note that an ornate "D" has been used in the title and, unlike in the previous ad, there is the added emphasis of an exclamation point.

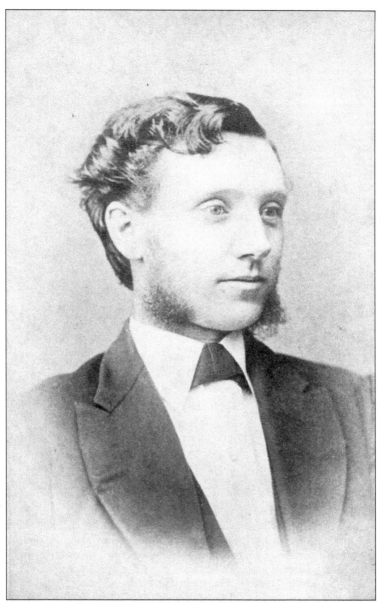

First Faculty Member: George Herod Ashley. George Herod Ashley was the first faculty member hired at Drury College. Born in England in 1844, he was raised in America and graduated from Olivet College, where President Morrison had treated him as something of a protégé and surrogate son. Hired as a professor of English and classical literature, Ashley was an inspiring teacher but was also described as "nervous and intense." Indeed, he had a temper, and when that temper was provoked, his eyes would flash and he would shake his hair. That temper was aroused in 1875 when President Morrison added music to the curriculum at Drury. Ashley and others believed that the program was hampering the primary mission of the college, and soon Ashley emerged as the leader of the anti-music faction. When Morrison began to believe that Ashley was undermining his presidency, he called for his resignation. On July 14, 1877, Ashley presented his resignation to the board of trustees. He went home, fell ill, and died six days later. He was only 32 years old. His gravestone reads, "I Have Given My Life to Drury College."

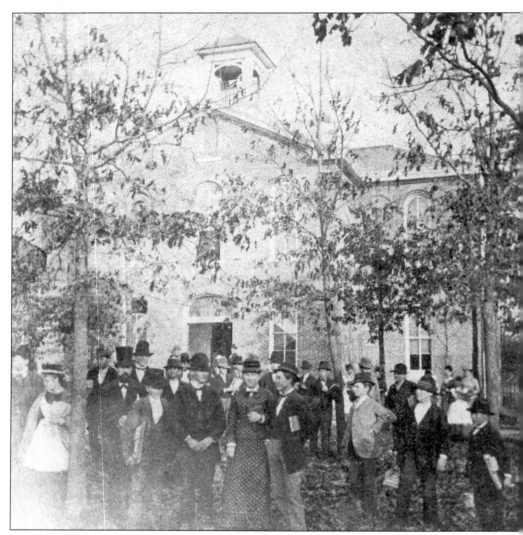

FIRST DAY OF CLASSES, 1874. Drury College opened its doors for classes on Thursday, September 25, 1873, at 1:30 in the afternoon. Unfortunately, there is no known image that survives of that first day of school. A photographer was on hand, however, when classes started the following year on the morning of Thursday, September 10, 1874. The original source for this rather blurred image was a small stereotype photograph. It shows students of Drury College and Drury Academy (a preparatory school run by the college from 1873 until 1914) standing in front of the institution's first building before classes started. That fall, there were 24 college students enrolled and 102 students enrolled in the preparatory program. The following spring, Drury would graduate its first class of five college students, all of whom were women.

Two

THE CAMPUS

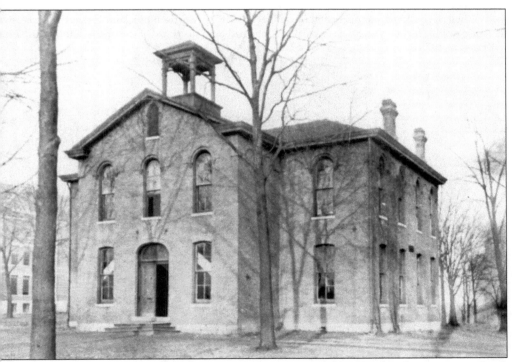

THE ACADEMY BUILDING. Drury's first building was the Academy Building, a plain, two-story brick structure. It provided classrooms not only for the institution's college students but also for students of the Drury Academy, a preparatory school that Drury operated until 1914. On the first day of classes, it was not fully finished. Some donors complained that they were "promised a college" but instead given a "little imitation" of a "schoolhouse." It was razed in 1910.

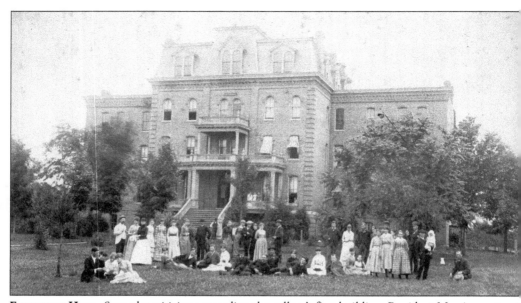

FAIRBANKS HALL. Stung by criticisms regarding the college's first building, President Morrison set out to construct a more impressive structure. Charles Fairbanks pledged $15,000 for a building that would commemorate "the fragrant memory of [his] only son and child," Walter Fairbanks, who had recently died. When the building was opened in the fall term of 1876, Morrison proclaimed that the impressive structure would "silence that crowd of croakers" who had been so critical of the first building. Fairbanks was razed in 1978.

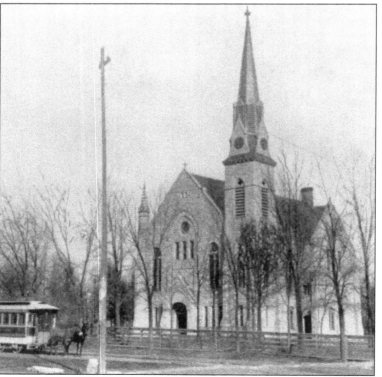

STONE CHAPEL. Although it is a limestone structure, Drury's chapel is named not for its appearance but after the benefactor who made its construction possible, Valeria Stone of Malden, Massachusetts. In December of 1882, just as the construction was being completed, the building caught fire (due to an improperly installed furnace) and was completely destroyed. It would take a decade to rebuild the chapel, which was finally opened in the spring of 1892.

THE WHITE HOUSE. The White House sat to the east of Stone Chapel. It was constructed in the spring of 1883 to provide temporary space while the recently burned Stone Chapel was being rebuilt. It would serve variously as a classroom building, a gymnasium, an armory for the cadet corps, a home for Drury's early music program, a clubhouse, and later as Scotts' Kindergarten. The structure was razed in July 1951.

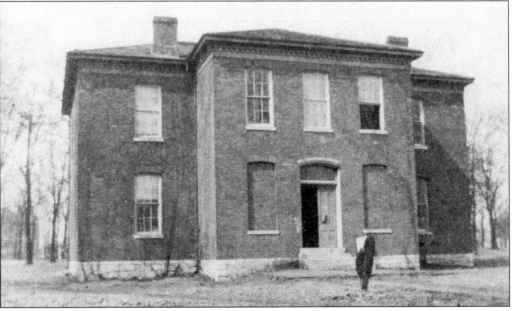

EAST ACADEMY BUILDING. Built in 1872 as the Washington Avenue Colored Public School, this structure stood east of Drury's Academy Building and served as the school for Springfield's African American children. In 1883, after a contentious public ballot referendum, the City of Springfield sold the building to Drury. Drury, in turn, agreed to build a new school for Springfield's African American students. Usually referred to as the East Academy or Museum Building, the structure was razed in 1914.

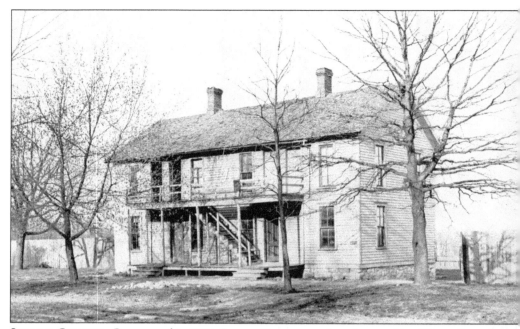

SPENCER COTTAGE. Constructed in 1885, Spencer Cottage stood on the east side of Drury Lane. It was named in honor of Spencer, Massachusetts (the birthplace of Samuel F. Drury), whose inhabitants had donated $1,000 for the founding of the college. It housed 12 students and was nicknamed "The Club." The building was later used as the office and printshop for Drury's campus newspaper, the *Mirror*. The structure was razed in 1908.

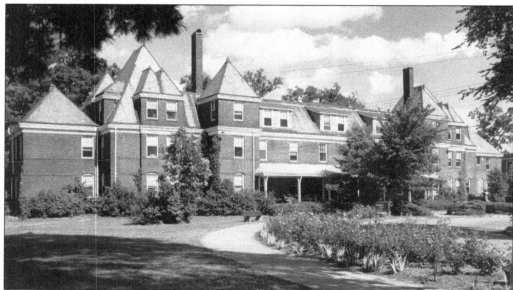

MCCULLAGH COTTAGE. McCullagh Cottage was the second "ladies' hall" built on campus, the first being Fairbanks. It was financed by a gift from E.A. Goodnow of Worcester, Massachusetts, who asked that it be named in honor Delores McCullagh, the wife of Goodnow's pastor. McCullagh ended its career as a temporary home for the Kappa Alpha fraternity before being razed in 1969 to make way for the construction of the Findlay Student Center.

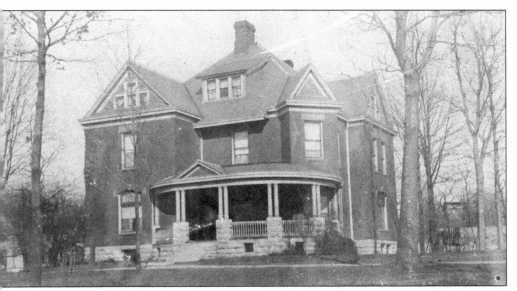

PRESIDENT'S HOUSE. Drury College's first two presidents had been housed in a somewhat haphazard fashion. When Drury's third president, Dr. Homer Fuller, was hired in 1894, the college trustees felt that it was time to give a proper home to the chief officer of the institution. Accordingly, in 1895, the president's house was constructed at the northwest corner of the campus. Since then, most of Drury's presidents have made it their home.

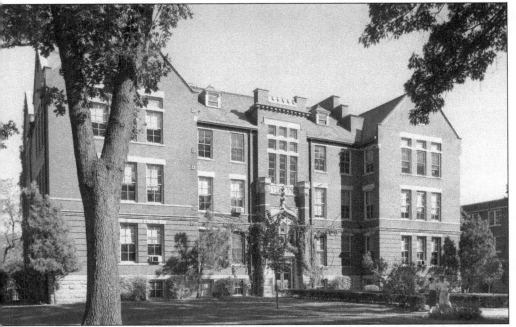

PEARSONS HALL. In 1898, Dr. Daniel K. Pearsons of Chicago—described by one source as an "eccentric philanthropist"—pledged $25,000 for the construction of a science hall, provided that Drury could match the gift. By 1901, President Fuller had raised that amount, and construction was started on Pearsons Hall. Completed in 1902, it was at the time considered one of the best examples of a collegiate science hall in the country.

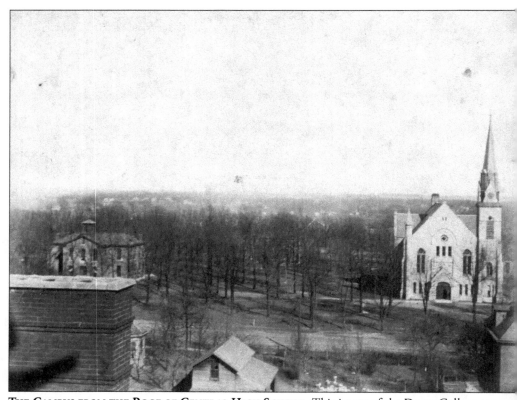

THE CAMPUS FROM THE ROOF OF CENTRAL HIGH SCHOOL. This image of the Drury College campus from the roof of Central High School was probably taken about 1900, before Pearsons Hall was constructed (1902–1903) and before the Academy Building, seen here on the left, was razed in 1910. Stone Chapel stands on the right, and the outline of the East Academy Building can just be made out through the trees in the center of the image.

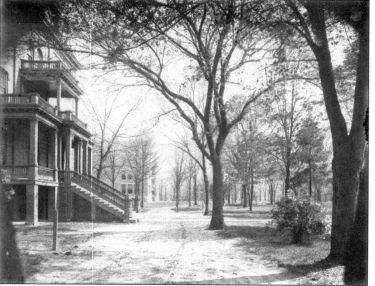

"THE DRURY WALK," ABOUT 1905. This image, reproduced from a glass-plate negative, shows the view of the path, sometimes called "the Drury Walk," that stretched from Fairbanks Hall to the southern end of the campus. On the left are the steps of Fairbanks, and beyond is Pearsons Hall on the left. Farther down, at the center of the image, are the windows of the Academy Building. Beyond that, one can just make out Stone Chapel.

SOUTH GYM/SPRINGFIELD HALL. Drury's first gymnasium was built in 1909 with donations from the citizens of Springfield. At the time of its construction, the building incorporated a number of innovative features, including an elevated running track slung above the gymnasium floor. After the advent of Weiser Gymnasium in 1948, it was referred to as the South Gym. In 1999, the building was renovated for a variety of uses and renamed Springfield Hall.

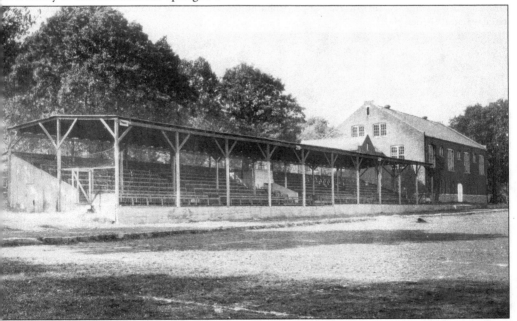

GRANDSTAND. In 1910, a wooden grandstand was built on the west side of the athletic field for the princely sum of $1,000. Perhaps the greatest moment its history came on September 23, 1912, when Teddy Roosevelt, then the Progressive (or "Bull Moose") Party's presidential candidate, delivered a campaign speech there. The grandstand survived until at least 1938, but at some point over the following decade, the structure was razed.

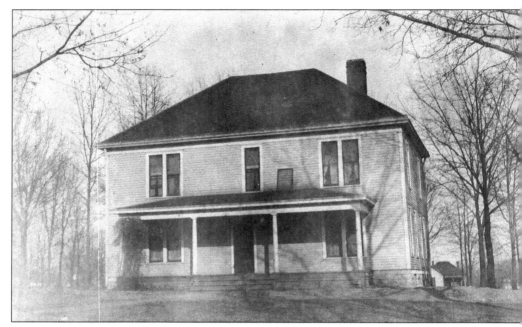

WOODLAND COTTAGE. This frame farmhouse originally sat on the current site of the Olin Library. It served as the home of Drury's first president, Nathan Morrison, and was later used as a dormitory for male faculty. In 1903, it was moved to the east side of Drury Lane, and for four decades, it served variously as a dormitory, infirmary, Kappa Alpha house, and faculty duplex. In 1947, it was razed to make way for Turner Hall.

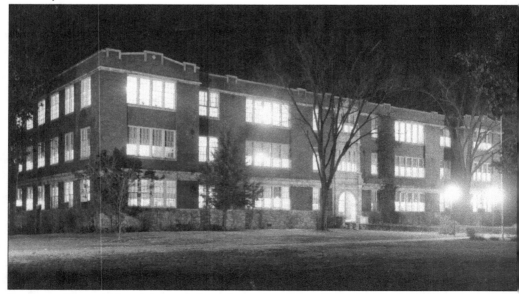

BURNHAM HALL. Although it was dedicated in early 1910 as Classical Hall, this building was shortly thereafter named in honor of trustee and benefactor J.K. Burnham of Kansas City. The initial concept for the building called for a much grander structure, but such plans were eventually scaled back. Burnham was the scene of one Drury's most famous pranks, when a small car was discovered one morning in its third-floor hallway.

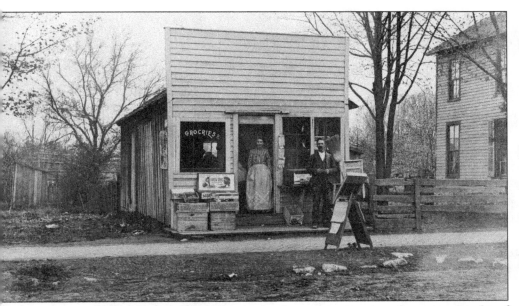

THE ARISTOCRAT. Though not a college building, this diminutive store was a fixture on the edge of Drury's campus in the early 1900s. It faced what was then called Center Street (now Central Avenue) and sold a variety of goods, particularly sweets, that made it a popular haunt of students. In what was perhaps a bit of self-deprecating humor, the proprietor of the simple little emporium named it The Aristocrat.

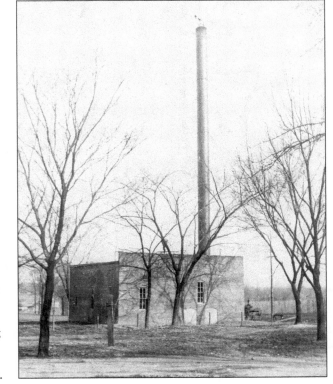

THE POWER PLANT. As Drury College expanded and as the use of electricity became common, the institution found it necessary to construct a central heating and lighting plant. This structure, which included a large coal bunker, sat to the north of the athletic field and was built around 1909. The building appears to have still been extant in the early 1980s; records show that it was probably razed in the mid-1980s.

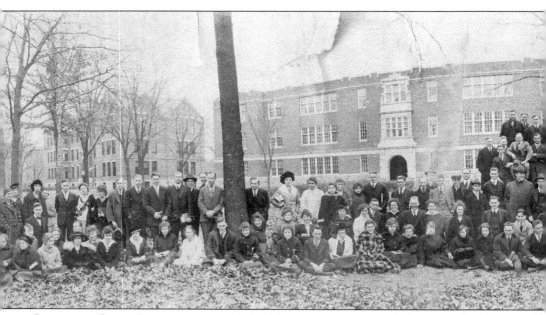

PANORAMIC GROUP PORTRAIT, ABOUT 1912. Although this group portrait is a wonderful human study of the Drury community, it also illustrates the layout of campus. To the far left is Fairbanks Hall; continuing to the right is Pearsons Hall. Burnham Hall is at center, and behind the right corner of

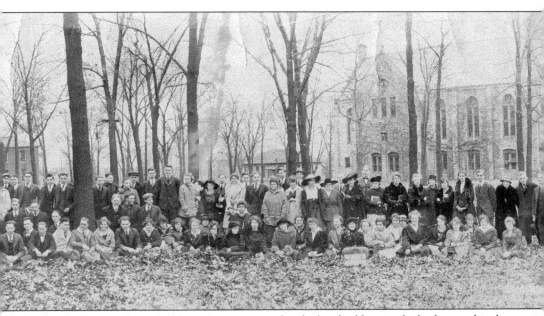

Burnham is the East Academy Building. Continuing right, the low building in the background is the White House, and Stone Chapel is at the far right.

WALLACE HALL. Constructed in 1926 as a women's dormitory, Wallace Hall was a gift of Louise Groesbeck Wallace of Lebanon, Missouri, in memory of her husband, Washington Irving Wallace. Dedicated in February 1926, the building contained 18 suites, each with two double rooms connected by a shared bathroom, as well as living quarters for the dean of women and a head resident. A wing was added to the building in 1956.

CLARA THOMPSON HALL. The Clara Thompson Hall of Music was another gift from Louise Wallace and was dedicated in June 1926 to the memory of her adopted daughter, Clara Wallace Thompson. Its central feature is a large concert hall. In the late 1970s, north and south wings, named Lydy and O'Bannon Halls respectively, were added. For many years, CTH, as it is commonly known, has been said to be haunted.

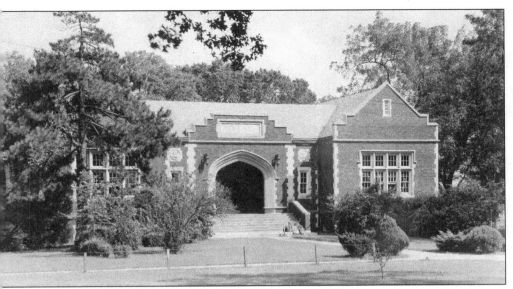

HARWOOD LIBRARY. Charles E. Harwood, one of the founders of Drury, remained involved in the institution's affairs until his death in 1933, three months shy of his 103rd birthday. In 1924, he donated 50,000 for the construction of a library to be named in honor of his wife. Construction on the Harwood Memorial Library was completed in 1926; the building was razed in 1991 to make way for the Olin Library.

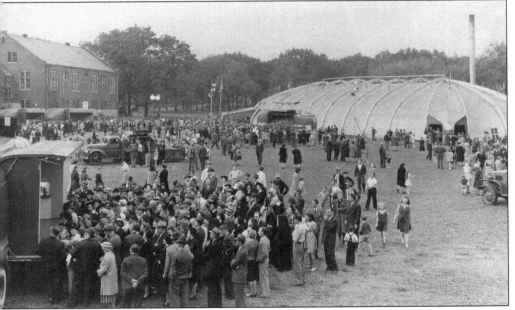

GM PARADE OF PROGRESS, OCTOBER 1941. The General Motors Parade of Progress was a travelling exposition that toured the country in the early 1940s. A central feature was a large air-conditioned tent, called the Aer-O-Dome, that was capable of seating 1,500 people. In addition, a fleet of Futurliners, streamlined bus-like vehicles, served as platforms for displays, lectures, and demonstrations touting futuristic technologies. This image shows the exposition set up on Drury's athletic field; 85,000 people attended.

BELLE HALL/THE COMMONS. Postwar growth of the student population made it necessary to expand the Commons, Drury's dining facility. A gift from trustee Lester Cox allowed the size of the existing dining hall to be tripled. As construction progressed in 1947, Cox suggested that a second story be added to serve as a women's dormitory. The resulting dormitory, Belle Hall, was named in honor of his mother. The site of the building is now part of Kellogg Green.

WEISER GYMNASIUM. Completed in 1948, the core structure of the New Fieldhouse was the framework of a surplus World War II bomber hangar. Labor costs and a large share of the materials were paid by the Federal Works Agency. Due to hardwood shortages in the wake of the war, maple was unavailable, so a pecan-wood floor was installed. In 1971, the fieldhouse was renamed Weiser Gymnasium in honor of longtime Drury coach A.L. Weiser.

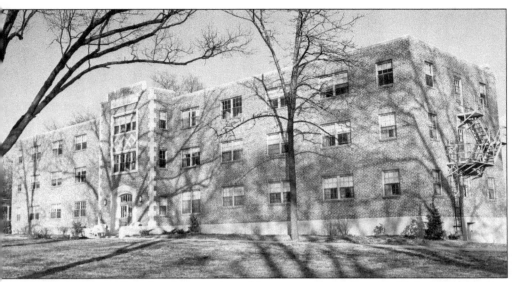

TURNER HALL. Originally referred to simply as "the new men's dormitory," this building was later renamed in honor of Lyman Turner, a college trustee. Constructed in 1947–1948, it was at the time considered the most modern and comfortable men's dorm. And while there was talk about refurbishing and modernizing the building, it was razed in 2014.

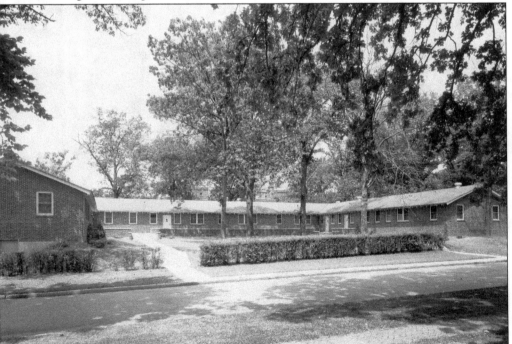

PAN-HELLENIC BUILDING. After World War II, Drury planned to build a sorority suite complex but could not raise the funds to do so. As a temporary measure, Drury purchased two surplus buildings in 1955 from the O'Reilly Military Hospital, moved them to campus, and put a brick facia over their exteriors. This horseshoe-shaped building served as a sorority building until it was razed in 1993 to make way for the Freeman Panhellenic Building.

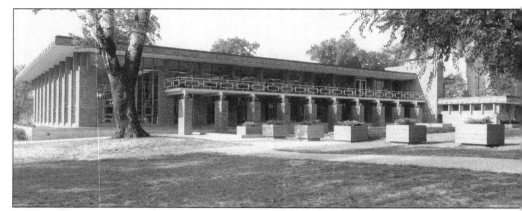

WALKER LIBRARY. Walker Library, named in honor of trustee and benefactor Theodore Walker (1908), was designed by another Drury graduate, Richard Stahl (1936). As the first "modern" building on campus, its appearance displeased some traditionalists. Upon first seeing Stahl's initial renderings, though, librarian Mary Hinkley remarked, "Mr. Stahl, that's the most beautiful building I've ever seen!" Dedicated in 1959, the following year, Walker Library was presented with an American Institute of Architecture Medal Award.

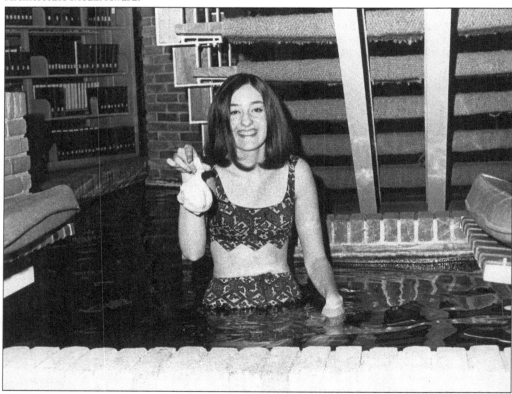

WALKER LIBRARY INDOOR POOL. Among Walker Library's unique design features were a balcony, a hearth room with a fireplace, and a set of fountains in front of the building. It also contained a small interior pool where students sometimes dabbled their feet or, at least on this occasion, engaged in a more immersive experience. Today known as Bay Hall, the fountains and the pool are gone, and the building houses several campus administrative offices.

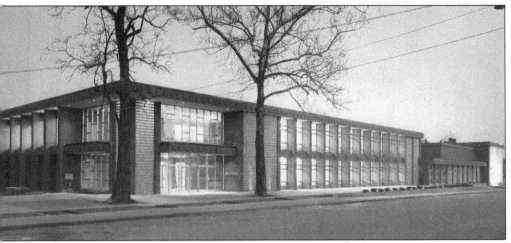

BREECH SCHOOL OF BUSINESS. In 1957, Drury alumnus Ernest Breech, then chairman of the board of Ford Motors, donated $500,000 for the creation of a school of business administration and economics. Additional money from the Ford Foundation funded the development of a cutting-edge undergraduate curriculum in business and economics. In 1963, a master of business administration degree was added to the school's offerings. The building, another design by architect Richard Stahl, was dedicated on April 28, 1960.

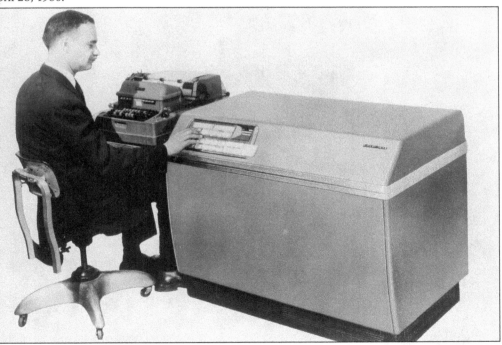

LGP30 COMPUTER FOR THE BREECH SCHOOL. When the Breech School of Business was dedicated in 1961, there was much fanfare surrounding the school's acquisition of a Royal Precision LGP30 Electronic Computer, described by the manufacturer as a "stored-program general purpose electronic digital computer capable of solving a wide range of business, statistical, scientific and engineering problems of extreme complexity." The computer was donated by P.M. Zenner, president of Royal McBee in Springfield.

SUNDERLAND HALL. In the postwar enrollment boom, housing students was a constant challenge. In 1959, Drury secured a loan of $250,000 from the Federal Housing Agency for the construction of a new men's dormitory. Estimated costs were $330,000, and the Lester T. Sunderland Foundation provided an additional gift to meet the shortfall. The building was opened in 1961 and razed in 2003 to make way for the new dormitory by the same name.

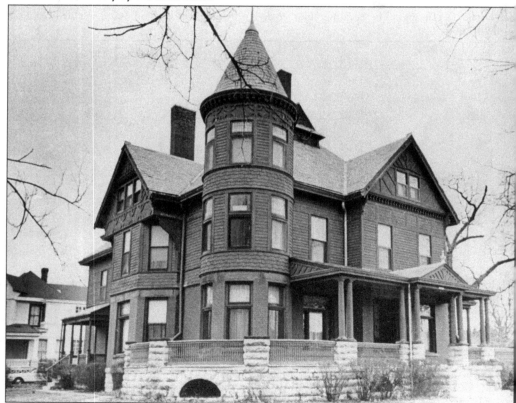

BENTLEY HOUSE. The Bentley House was built in 1892 by J.F.G. Bentley, a banker, and was purchased by Drury in 1965. It was used as an international house for students studying foreign languages and was also used for receptions and other special events. In 1977, it was leased, and subsequently purchased, by the Museum of the Ozarks. In 1993, the house was sold to a private owner.

SMITH HALL. In 1965, the Executive Committee of the Drury Board of Trustees recommended the construction of a new dormitory to address the increased need for women's housing. Their proposal called for a three-story structure and specified that it should be air-conditioned. The building was opened in 1967 and is named in honor of trustee Dr. C. Souter Smith and her husband, Dr. Wallis Smith (1908), who was also a trustee.

LAY SCIENCE CENTER. In addition to a generous gift from PepsiCo board chairman Herman Lay, Lay Science Center was financed by a loan and grant through the Higher Education Facilities Act of 1963. It was designed by the architectural firm of Warren and Goodin and, according to Drury professor Thomas Parker, was intentionally cast in the Modernist mode "to symbolize the institution's *future* aspirations." Today, Lay Hall houses Drury's School of Education.

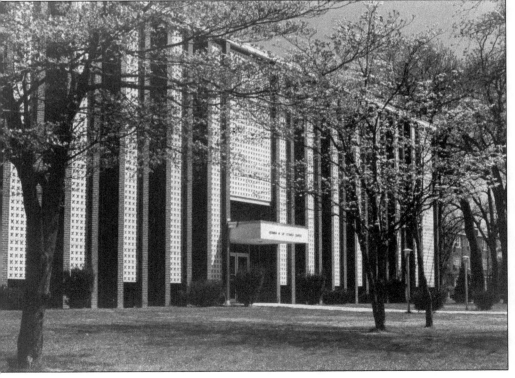

FINDLAY STUDENT CENTER. In the late 1960s, the need for a new dining facility and student center became critical. Planning for such a facility was complicated by economic conditions, difficulties in securing financing, and a series of disruptions in the leadership of the college. But ground was broken in November 1970 on the $1.8-million project. Dedicated in 1972, the building is named in honor of James Franklin Findlay, Drury's longest-serving president.

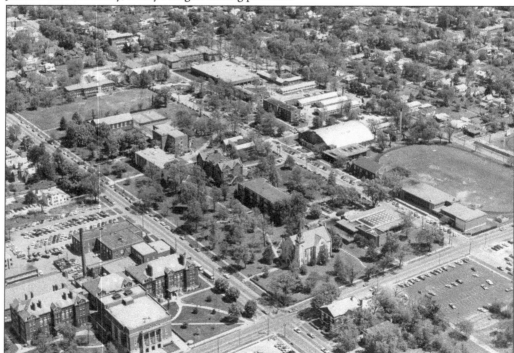

AERIAL VIEW OF CAMPUS, SUMMER OF 1972. This aerial photograph was taken in the summer of 1972, soon after Findlay Student Center, the large flat-roofed structure at the top center, was completed. To the right of Findlay, and slightly south, one can see the World War II hutments that were used as temporary structures—most of which would be razed over the following 20 years. At this point, the ornate mansard roof has been removed from Fairbanks Hall.

HPER: The Hutchens "Hyper." Built as an addition to Weiser Gymnasium, the Health, Physical Education, and Recreation (HPER, or "Hyper") complex is named in honor of Lewis Hutchens, a Springfield businessman. It contains a basketball court, handball courts, classrooms, offices, changing rooms, and a concession stand. Dedicated in 1988, the most prominent feature of the HPER is the 10-lane, 25-meter Breech Pool, which is used primarily by Drury's top-ranked NCAA-II swimming teams.

Shewmaker Communication Center. Opened in 1989, the Shewmaker Communication Center was the result of a large lead gift from Jack Shewmaker, trustee, benefactor, and an executive with WalMart, and his wife, Melba Prosser Shewmaker. The building features a production studio, a broadcasting center, digital media editing rooms, classrooms, and offices. It houses not only the Communication Department but also offices for the campus newspaper, the *Mirror*, and the student-operated radio station, KDRU.

HAMMONS SCHOOL OF ARCHITECTURE. After a somewhat shaky start, Drury's School of Architecture was established in the mid-1980s as a signature program, one that would blend the liberal arts with a course of professional study. Initially, the program was housed in the aging Harwood Library building. Pres. John Moore secured funding from Springfield businessman and philanthropist John Q. Hammons for the construction of the Hammons School of Architecture building, which opened in 1991.

F.W. OLIN LIBRARY. Constructed with a $6.1-million grant from the Olin Foundation, Drury's current library was dedicated in October 1992. Built on the site of the old Harwood Library, the building incorporates a number of architectural features salvaged from that building. Drury's Olin Library was one of the last buildings funded by the F.W. Olin Foundation before the foundation redirected its resources to the Olin College of Engineering.

Freeman Panhellenic Building. In 1994, the aging sorority complex was replaced with a more suitable home, Freeman Hall. A gift of alumnus and longtime trustee Flavius Freeman and his wife, Frances, it was named in honor of their daughter, Mercedes "Dede" Freeman Smith, former director of Drury's Center for Gifted Education. The building contains chapter rooms for Drury's sororities, a central meeting hall, the Hoblit Room (named for alumna Marian Hoblit), and kitchen facilities.

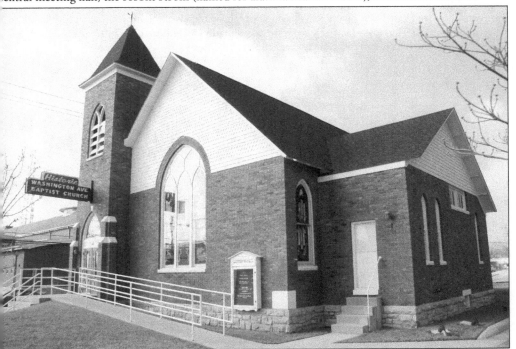

The Washington Avenue Baptist Church. Built in 1885, the Washington Avenue Baptist Church is the oldest extant African American church building in Springfield. When Drury acquired the building in 2000, it was understood that the structure would have to be moved to make way for Drury's new Trustee Science Center. At a cost of $650,000, the structure was disassembled, brick by brick, and rebuilt 100 yards to the north. It now serves as the campus diversity center.

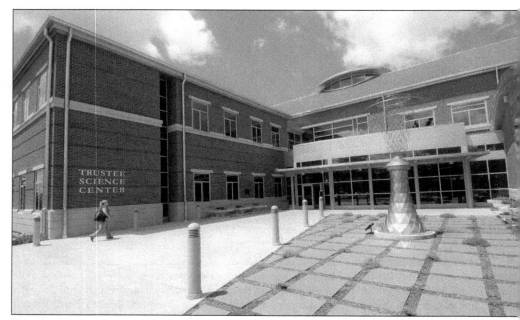

TRUSTEE SCIENCE CENTER. By the 1990s, it was obvious that the Lay Science Center was not adequate to the task of providing college-level scientific studies. Accordingly, Drury's trustees collectively provided the $8-million lead gift for a new science center, which was later named in their honor. The almost $20-million project was funded entirely from private donations. Dedicated in 2002, the TSC occupies almost 76,000 square feet and contains state-of-the-art facilities.

POOL ART CENTER. Originally a Coca-Cola bottling plant, this building now serves as the home for Drury's art and art history department. The renovation and conversion of the building was made possible by a gift from Earl Pool in honor of his sister, alumna and longtime trustee Mary Jane Pool (1946). Opened in January of 2004, the 23,000-square-foot facility features studios, classrooms, an art gallery, and faculty offices.

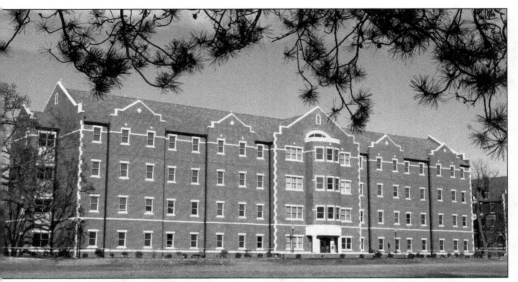

NEW SUNDERLAND DORMITORY. The layout of postwar dormitories at many universities was one of double-occupancy rooms with a common hall bathroom. By the early 2000s, this model was becoming increasingly unpopular with students, who desired a more "home-like" environment. To respond to such preferences, the old Sunderland dormitory was razed and replaced in 2005 with a four-story building. The new Sunderland Hall features individual rooms and bathrooms shared by just two residents.

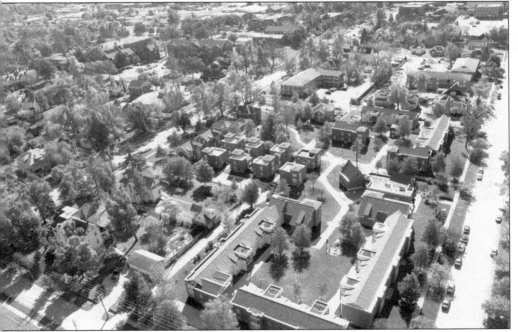

COLLEGE PARK. Part of the College Park complex is seen in this aerial view. Initiated in 1994, the first phase was the subject of a national architectural design competition; the last phase of the complex was completed in 1999. College Park includes a series of dormitory cottages (the small buildings at the center of the photograph), a more traditional housing complex surrounding a plaza (seen at the bottom center), a neighborhood center, and a security substation.

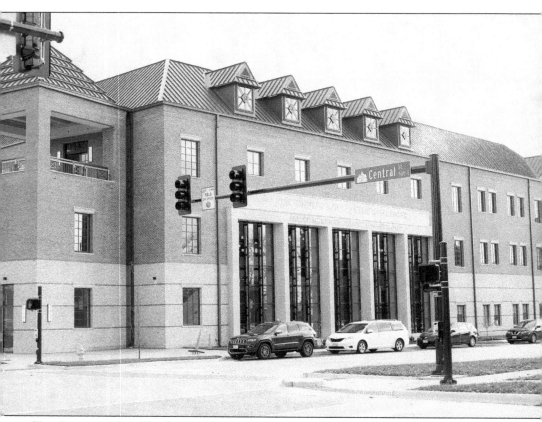

THE FUTURE: OBT. The first building to be constructed in Drury's new 25-year master plan is the C.H. "Chub" O'Reilly Enterprise Center and Breech School of Business and Judy Thompson Executive Conference Center, abbreviated as OBT, and referred to by many students simply as "The Chub." The ribbon-cutting to open the building took place on October 28, 2022. The new 67,000-square-foot building is the tallest academic building on campus and contains 46 faculty offices and 11 classrooms. The Judy Thompson Executive Conference Center has theater-style seating for 477 attendees. In addition to serving students studying business administration and its allied fields, OBT will also house the Meador Center for Politics & Citizenship and the Robert and Mary Cox Compass Center for student mentoring and advising, as well as the departments of mathematics, computer science, and political science and international studies.

Three

STUDENT LIFE
AND LEARNING

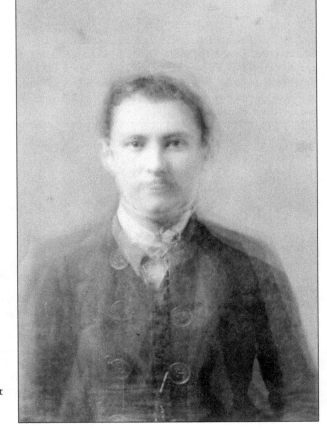

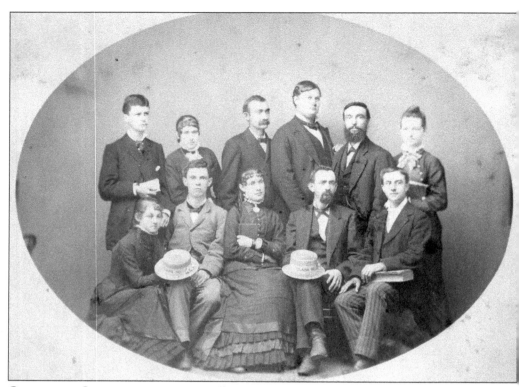

GRADUATING CLASS OF 1880. Drury College graduated its first class in June of 1875. The earliest known portrait of a graduating class is this one of the class of 1880. The graduates are, from left to right (seated) Jennie Sweet, Edward Townsend, Ada Durham, Milton Phillips, and Charles Curtis; (standing) James Townsend, Georgietta Hardy, Nathaniel Wheat, William Wieman, Seward Haseltine, and Gertrude Haseltine.

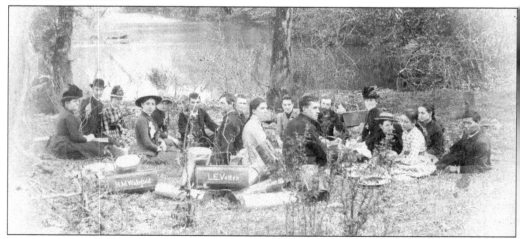

DR. SHEPARD AND BIOLOGY CLASS IN THE FIELD, 1886. An early faculty member at Drury College, Dr. Edward Shepard was a prominent biologist, geologist, and antiquarian whose tenure at Drury lasted from 1877 to 1910. Toward the end of his career, he would serve as dean of the college, librarian, and even acting president. Here, he poses with students in a botany class, probably along the banks of the James River.

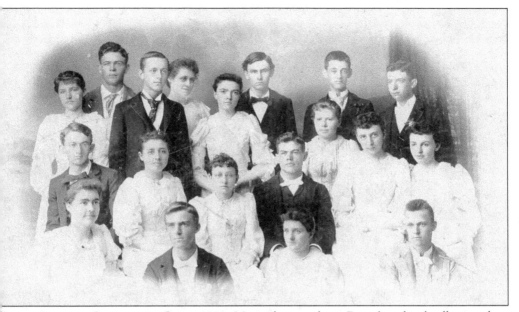

DRURY ACADEMY GRADUATING CLASS, 1892. Many photographs in Drury's archival collection show students who are obviously too young for college. These students were members of the Drury Academy, a preparatory school that Drury College ran from 1873 to 1914. When Drury was founded, the faculty felt that local schools were not adequately preparing students for college studies, so the academy was formed to address the issue. Here, the academy's graduating class of 1892 poses for a group portrait.

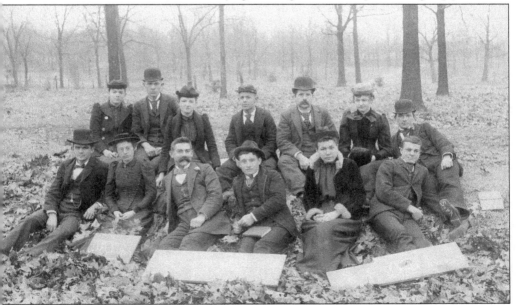

SOPHOMORE CLASS STUDENTS, SPRING SEMESTER 1893. The class of 1895 poses for a group portrait in the early spring semester of 1893. Note that the reclining student on the back row to the far right has the word "Soph" chalked onto the bottom of his shoe. The image captures the relatively wild look of the campus, which one contemporary observer described as "partly prairie and partly overgrown with scrub oak and sumac."

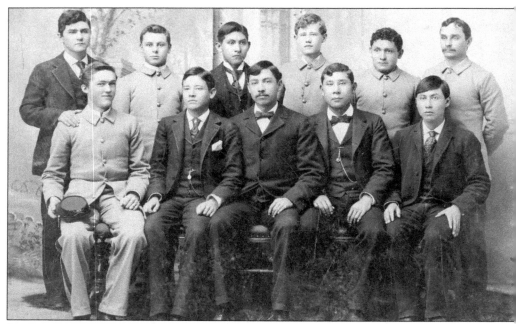

"THE INDIAN BOYS OF FAIRBANKS HALL," 1894. A group of Native American students poses for a portrait in 1894. From 1873 to the early 1900s, more than 200 students from the Oklahoma Indian Territory, or the "I.T." as it was referred to, attended Drury College or the Drury Academy. Most were Choctaws, although a number of students came from the Chickasaw, Cherokee, and other tribes. Many of these students later rose to prominence in their communities.

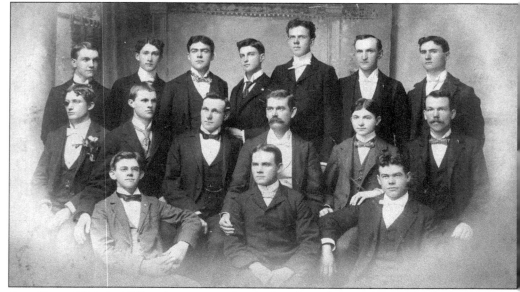

GLEE CLUB, 1896. In 1875, only two years after the founding of Drury, the institution started a music program known as the Missouri Conservatory of Music. Early attendees included Theron Bennett, who would later be a noted ragtime composer, music publisher, and owner of the Dutch Mill Café in Denver, Colorado. Here, members of the Glee Club pose for a group portrait in 1896; at center is William Chalfant, director of the conservatory.

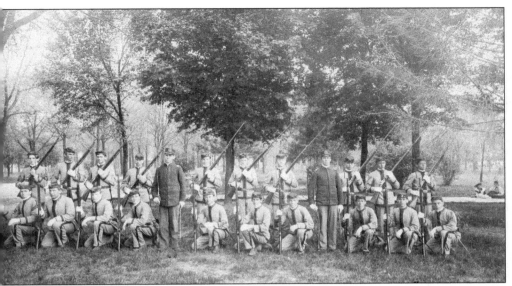

DRURY COLLEGE CADET CORPS, MAY OF 1898. The Drury College Cadet Corps (DCC) was founded in 1888. The DCC later became a unit of the Missouri National Guard, and some cadets were granted commissions by the governor. Interest in military science waned after World War I, particularly as pacifist sentiments became more pronounced on campus. Here, cadets assemble in May of 1898. The photographer seems to have carefully framed the image to include the young women sitting to the right.

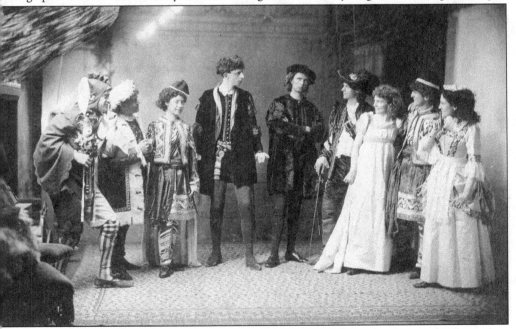

THE CAST OF *TWELFTH NIGHT*, SPRING OF 1898. On the evening of Tuesday, June 7, 1898, members of the senior class performed Shakespeare's *Twelfth Night* at the Baldwin Theatre. Here, the cast poses for a group portrait. From left to right, they are Fred Park (Feste), Marion Humphreys (Orsino), Grace Peale (Viola), Phelps Howland (Malvolio), Fred Appleby (Antonio), Lucian Smith (Roberto and the First Officer), Sadie Lichliter (Olivia), Guy Arey (Sebastian), and Eda Parks (Maria).

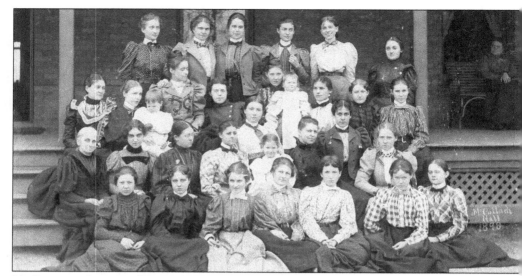

McCullagh Cottage "Family," Spring of 1898. Residence hall students and staff often posed for what were sometimes called "family" portraits. Here, the residents and "house mothers" of the McCullagh Cottage family assemble for a portrait in the spring of 1898. The children are those of the house staff. Given the formality of most photographs from the period, the full-fledged smile displayed by the young woman in the back row is unusual.

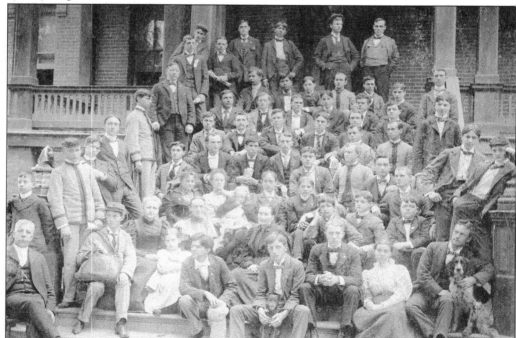

Fairbanks Hall Group Portrait, May of 1898. Drury's archival collection holds a number of group portraits taken on the steps of Fairbanks Hall. This image includes both college and academy students, several members of the cadet corps, and a pair of dogs. "Pater" Howland, longtime headmaster of the academy, sits to the side on the left. Several Fairbanks family portraits include the mailman, who sits at the bottom of the stairs on the left in this image.

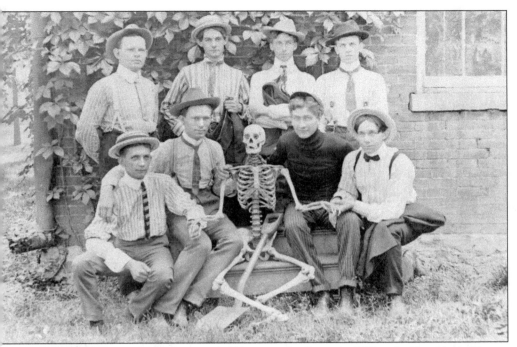

STUDENTS WITH TOBY THE SKELETON, 1902. Toby arrived at Drury in 1873 and still resides in Trustee Science Center. He takes his name from Shakespeare's *Hamlet*: a reference to Yorick's skull and Hamlet's "To be" soliloquy. While he was usually employed in anatomy classes, Toby was often used in pranks. Here, he poses with, from left to right, (first row) Triece Chandler, Emery Lowe, Frank Hull, and Harry Bagby; (second row) Charles Orr, Warren White, Paul Albert, and Edward Hall.

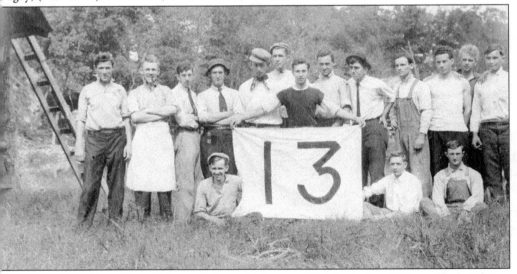

STUDENTS WITH CLASS FLAG, BROWNS SPRING, 24 AUGUST 1910. In the late 1800s and early 1900s, a college picnic was usually held in the countryside outside of Springfield. A hallmark of this outing was a mock battle, called "the scrap," in which the freshman and sophomore classes would try to capture each other's class flag. This free-for-all often resulted in bruises, scrapes, and torn clothing. Here, members of the class of 1913 display their flag, presumably before the battle.

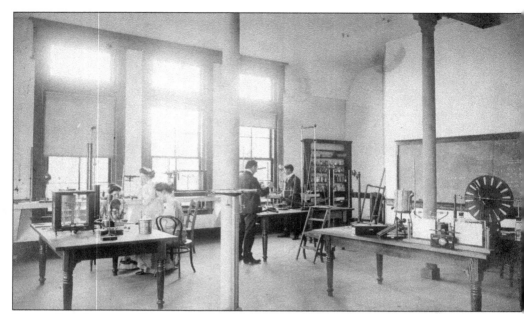

PHYSICS LAB, PEARSONS HALL, ABOUT 1915. Surrounded by a number of instruments, students conduct experiments in the Pearsons Hall physics lab about 1915. The cylindrical unit on the table to the right may be a vacuum chamber or condensing unit; the wheel at right appears to be part of a stroboscope.

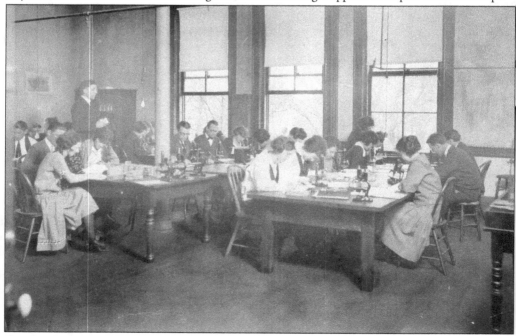

GENERAL BIOLOGY LAB, PEARSONS HALL, ABOUT 1920. While this scene might look antiquated to the modern eye, Pearsons Hall was for many years considered a state-of-the art science facility. In particular, it boasted a fire-suppression system and featured a flue-wall ventilation system that was built into the structure. Standing to the left is Dr. James Elias Cribbs, who had recently joined the faculty. He would teach at Drury until his sudden death in 1942.

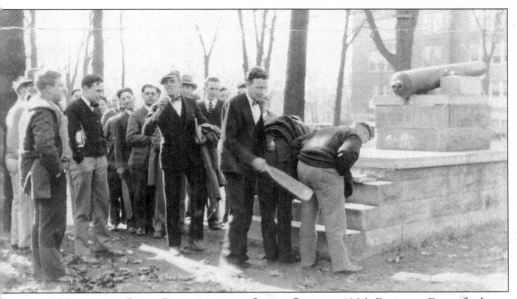

FRESHMAN MISCREANTS BEING PADDLED AT THE SOUTH CANNON, 1924. For years, Drury freshmen were hazed by upperclassmen. Freshman boys were required to wear a beanie cap, and freshman females had to wear a large bow in their hair. They were required to follow a number of rules, and those in violation had to appear before a "Doom Court," which imposed "punishments," including "licks" from a paddle. Hazing was discontinued after World War II, when returning servicemen refused to endure such humiliations.

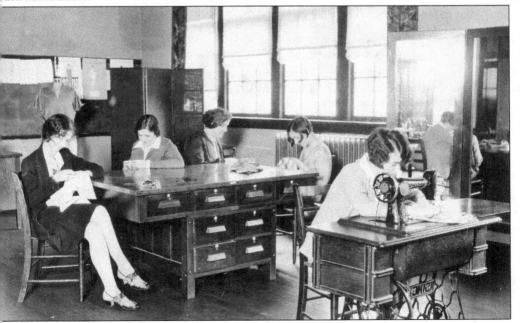

HOME ECONOMICS CLASS, 1927. A home economics program was started in 1917 offering majors in domestic science and domestic art. After a period of declining enrollments, coupled with budgetary issues in the mid-1970s, the program was eliminated. Here, students in a Home Economics 10 class work on clothing in the spring semester of 1927.

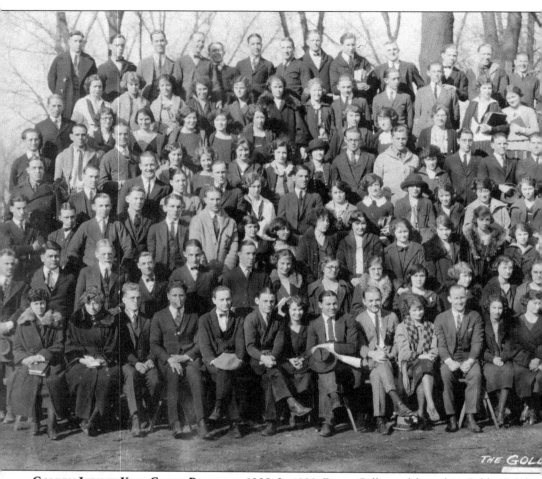

GOLDEN JUBILEE YEAR GROUP PORTRAIT, 1923. In 1923, Drury College celebrated its Golden Jubilee, the 50th anniversary of its first day of classes. That fall, scaffolding was erected in front of Burnham Hall, and the students and faculty assembled for this group portrait. On the second row from the bottom, fourth from the left, is Dean Arthur P. Hall. As a young man, he had attended classes on the day that Drury opened its doors on September 25, 1873. Dr. Benjamin Franklin Finkel, noted

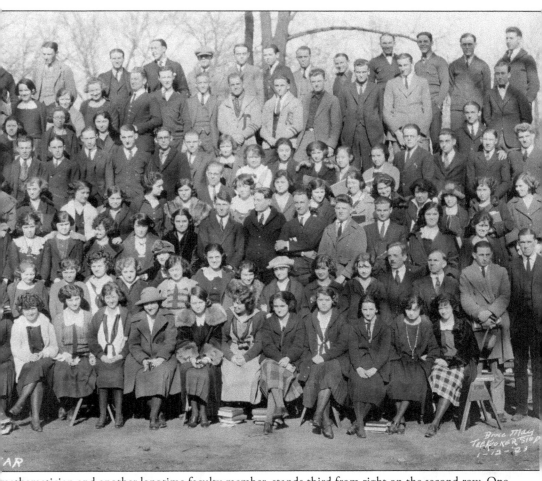

mathematician and another longtime faculty member, stands third from right on the second row. One row down from the top, standing somewhat to the right of center and striking a proud pose in profile with his hands in his jacket pockets, is then-student Oscar Fryer, who would later be a physics professor for many years at his alma mater.

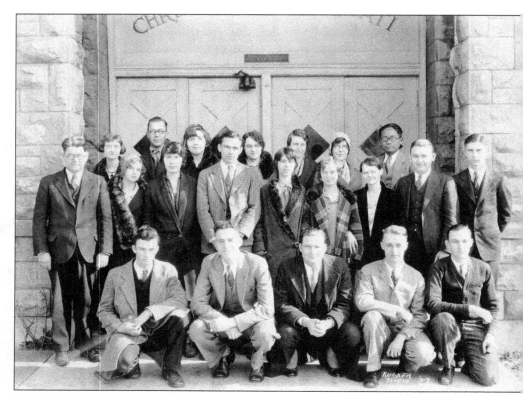

Dean Swift with Christian Fellowship Students, 1929. Drury College was founded by New England Congregationalists and initiated a school of religion in 1909 through the Disciples of Christ. In this group portrait, the dean of the School of the Bible, Dr. Carl Swift, at left, stands with students at the doors of Stone Chapel. Above the doors, one can make out part of the college motto, *Christo et Humanitati*, Christ and Humanity.

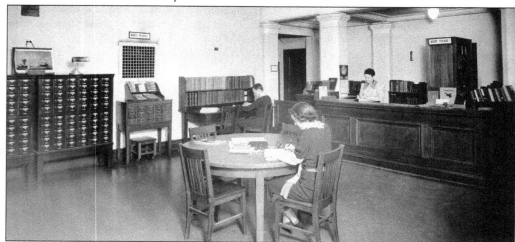

Students Studying in Harwood Library, 1938. This photograph of the interior of Harwood Library was taken in January 1938. The reading material reflects the tenor of the times. On the "Well Worth Reading" stand at the circulation desk, the book *Japan* is displayed. The January 1938 issue of *Current History* is on the table in the foreground. The man on the cover: Adolph Hitler.

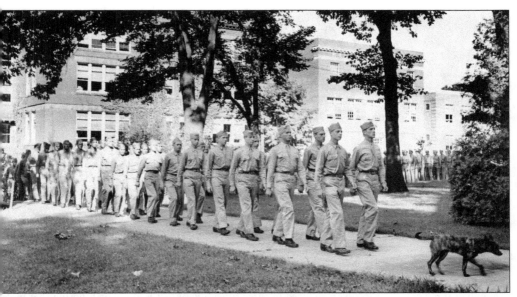

AIR CADETS MARCHING TO MATRICULATION CHAPEL, SEPTEMBER 1943. Before the United States entered World War II, Drury College had been a site for the US government's Civilian Pilot Training Program (CPTP). While presented as an initiative to benefit civil aviation, the CPTP was in reality a military preparedness program that aimed to create a pool of pilots available as a wartime contingency. When the United States entered the war, the US Army Air Force took over Drury's CPTP program, designating it the 340th College Training Detachment.

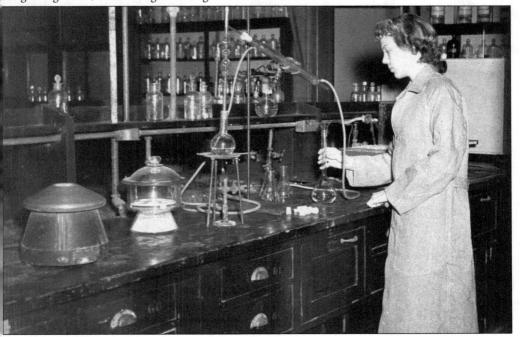

CHEMISTRY LAB, 1944. Donning a heavy denim lab coat, a student works in a Pearsons Hall chemistry lab in 1944. The student is Lucy Lee Neal (1945). She was the daughter of Dr. Roland Neal, who was professor of chemistry at Drury from 1920 to 1957.

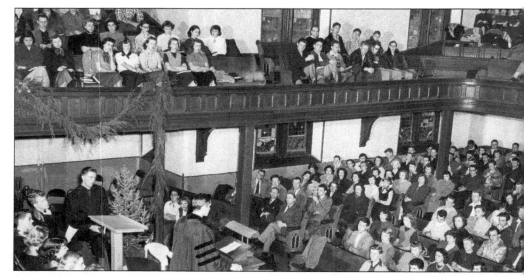

CHAPEL SERVICE, ABOUT 1948. Beginning in 1894, daily chapel attendance was required of all students, although at some point services were reduced to three times a week. (It is also worth noting that male and female students sat in separate areas of the chapel until 1931.) Mandatory worship services became a point of contention in the 1960s, and in the fall of 1968, the administration decided to make chapel attendance voluntary. Here, students attend a service in Stone Chapel around the fall of 1948.

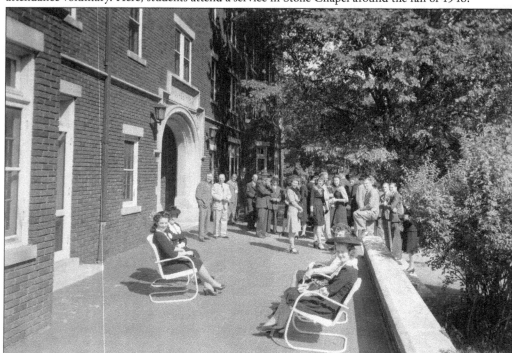

WALLACE HALL OPEN HOUSE, 1945. A tradition for many years was dormitory open houses or teas, usually held in the spring. Here, a group of students, faculty, and administrators entertain visitors (primarily parents) on the front veranda of Wallace Hall. The social mores of the time still required that women wear hats and gloves on such an occasion, and all of the men are wearing ties if not also hats.

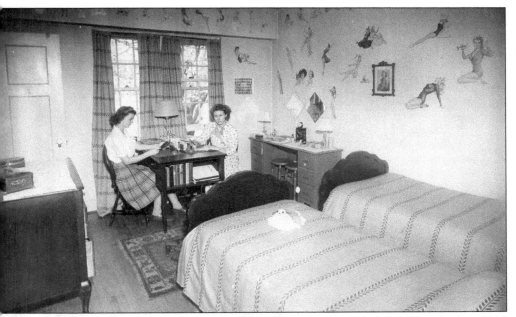

WALLACE HALL DORM ROOM, 1942–1943. Two students sit at their shared desk in Wallace Hall. While the furnishings in the room are somewhat spartan, it is decorated with cutouts of artwork by Alberto Vargas and similar artists pasted to the walls. And while the photograph itself is not dated, the Theta sorority composite on the wall behind the student on the right is dated 1942–1943.

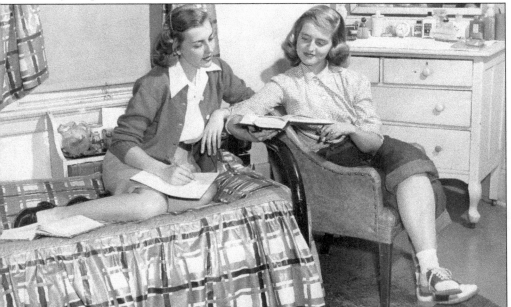

McCULLAGH COTTAGE SCENE, ABOUT 1950. In this somewhat more staged promotional photograph, roommates study in their McCullagh Cottage room about 1950. Constructed in the fall of 1894 as a women's dormitory, McCullagh had been pressed into service as a military barracks in World War II. After the war, it was given a good cleaning and a refemininized paint scheme and returned to its original role.

LAMBDA CHI ALPHA PARTY, 1949. Although its antecedent fraternities stretch back to 1910, the Theta Sigma chapter of Lambda Chi Alpha was established at Drury in 1939. Here, High Beta Edward Wulfekuehler (1950), right, presents High Epsilon Richard Mourglia (1951) at a party in the fall semester of 1949.

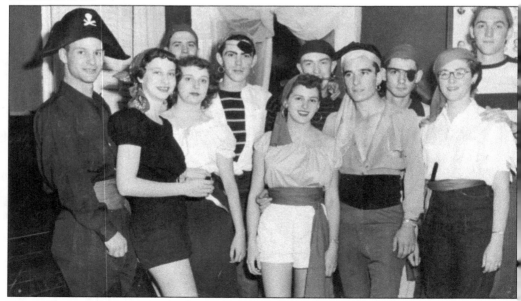

PIRATE-THEMED PARTY, 1951. Students pose in costume at a pirate-themed fraternity party in 1951. Although dormitory curfews were still in effect, chapel attendance was still mandatory, and a dress code continued to be enforced for dining in the campus commons, this image perhaps illustrates how social norms and ideas about appropriate dress and behavior were starting to change in the wake of World War II.

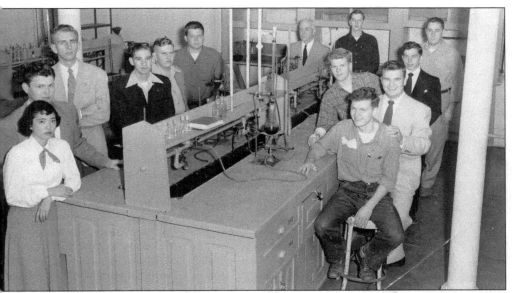

CHEMISTRY CLUB, 1952. Members of the Chemistry Club pose for a yearbook photograph in 1952. From front to back are (left) Eleanor Shim, Donald Thompson, Jerry Bartlesmeyer, Lindal Arnhart, Darel Viles, Sam Compton, sponsor Dr. Roland Neal, and John Evans; (right) Earl Hackett, Charles Thompson, Irvin Heimburger, Everett Collier, and Roy Kenney.

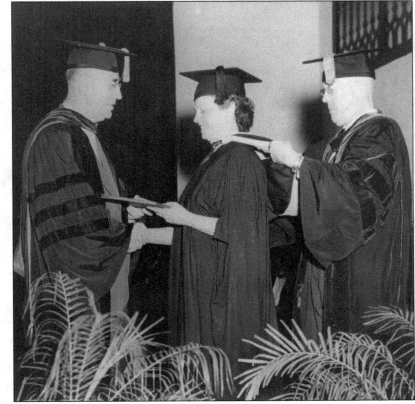

FIRST MASTER'S DEGREE, AUGUST 6, 1954. Mary C. Robinette receives her master's degree in education from Pres. James Finlay, while Dean Frank Clippinger invests her with the requisite hood. Although this event was celebrated as Drury's first master's degree granted, the institution had awarded a number of master's degrees in the late 1800s and early 1900s.

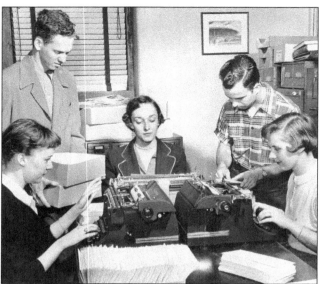

MEMBERS OF THE STUDENT UNION BOARD AT WORK, APRIL 1953. While the idea of a student union was born in the early 1900s, the Student Union Board of Governors did not emerge until the fall of 1947. This group of student leaders coordinated student activities such as ballroom and square dances, movie nights, concerts, Ping-Pong tournaments, and talent shows. Here, members of the Student Union Board address invitations for parents to the annual student talent show, "State of the Union." From left to right are (seated) Nancy Jones, LuAnn Crow, and Donna Brady; (standing) Donald Cunningham and Bert Ronsick.

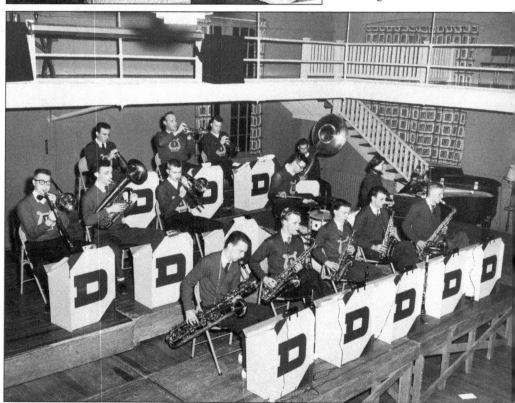

DRURY BRASS BAND CONCERT. Members of the Drury College Brass Band give a campus concert in March 1955. The location is on the basketball court floor of the old South Gym, recognizable by the elevated running track, which can be seen in the top portion of the image. The South Gym was a popular venue for events ranging from lectures and dramatic performances to square dances and ice cream socials.

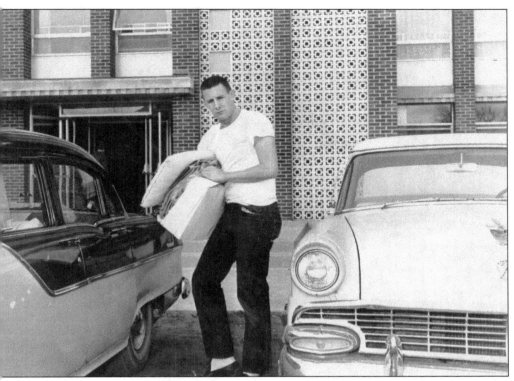

Move-In Day, 1961. One ritual in the rhythm of life on a college campus is move-in day. Here, junior Dick Mann carries an armful of bedding as he moves into the newly constructed Sunderland Hall in the spring semester of 1961.

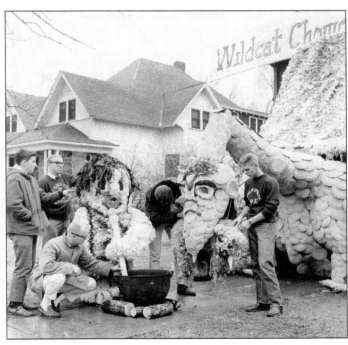

Sigma Phi Epsilon Homecoming Decorations, 1964. Drury's chapter of Sigma Phi Epsilon (Missouri Delta) was installed nationally in 1949 but dissolved in 1988. Here, Sig Eps work on their fraternity house homecoming decorations in February 1964. (In a departure from tradition, there was no homecoming parade that year.) The opposing team were the Wildcats of Culver-Stockton, and the Sig Ep decorations, entitled "Wildcat Chowder for Our Alma Mawter," won first prize.

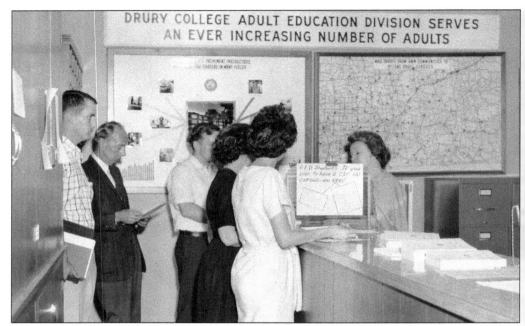

Adult Education Students Register for Classes, 1966. While Drury College officially launched its adult education program in 1947, it offered a "summer school of instruction" for nontraditional students as early as 1889. Having celebrated its 75th anniversary in 2022, the program continues today as DruryGO: "global and online." Here, adult education students register for classes in Burnham Hall in the spring of 1966.

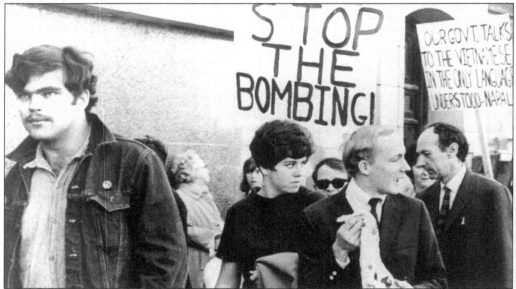

Students and Faculty Protest the War in Vietnam, 1967. On November 11, 1967, a group of Drury students and faculty held a March for Peace through downtown Springfield. The demonstration took place immediately after a Veterans Day parade, and according to one report, the protesters "were confronted with violent opposition, which required police intervention." At far right is Dr. Richard Mears, a longtime professor of English and veteran of World War II.

Riding Down Drury Lane, 1970. Rick Ayre (1971), sporting a fringed-leather jacket and bell-bottom jeans, cruises down Drury Lane on a stingray bike. Although Drury did not see the sort of intense activism that many colleges of the period experienced, there was something of a counterculture on campus that disturbed some of the school's more conservative trustees. As editor of the campus newspaper, the *Mirror*, Ayre caused controversy by publishing material critical of the Vietnam War.

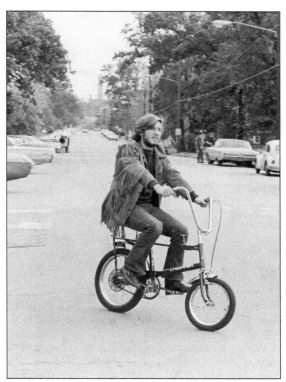

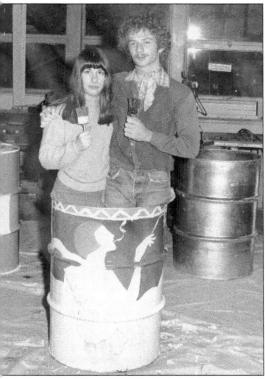

Art Students Painting Barrels, 1974. The 1960s and 1970s saw an increasing concern about caring for the environment on many campuses, and Drury College was no exception. One student initiative at the time was to place empty 55-gallon drums around the campus to serve as trash cans. Here, a pair of students stands in a barrel after transforming into a somewhat more attractive litter receptacle.

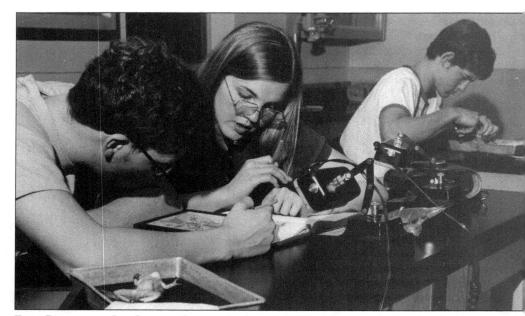

FROG DISSECTION, LAY SCIENCE CENTER. In the early 1960s, it became obvious that the campus sorely needed a new science building, one that would allow student learning to keep up with the rapid pace of change in the sciences. Herman W. Lay, of Frito-Lay fame, provided the lead gift for a modern science building, which was dedicated in 1969. Here, students in a biology class dissect frogs in a Lay Hall laboratory about 1975.

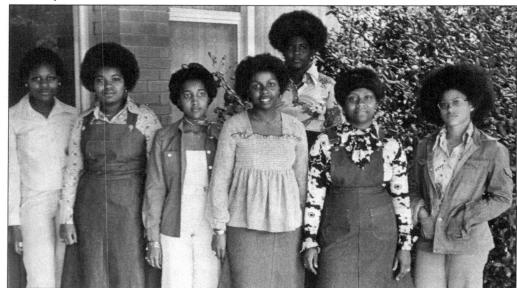

THE LADIES OF DISTINCTION, 1975–1976. In 1945, trustee Lyman Turner inquired "whether the color of a prospective student's skin should be a determining factor in [their] matriculation at Drury College." In the years that followed, Turner and others repeatedly called for the admission of "colored" students. Despite this, Drury did not admit its first African American student until 1964. What followed in the 1970s can only be described as a blossoming of an African American student presence on campus, including chapters of national organizations like the Ladies of Distinction.

DRURY CHEERLEADERS, 1981.
Drury has had an official cheering squad of some sort since at least the 1920s. Here, the cheerleaders pose for a group portrait in 1981. Today, Drury's cheer squad not only leads cheers at athletic events, the squad itself is a coeducational non-NCAA sport team.

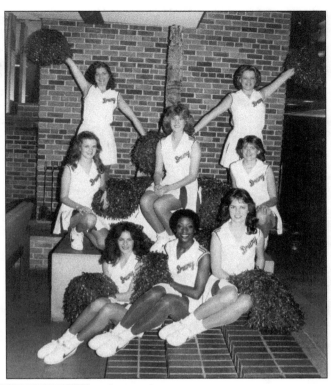

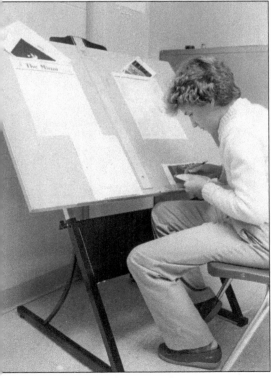

LAYING COPY OUT FOR THE *MIRROR*, 1981. Drury's campus newspaper, the *Mirror,* was first published on September 24, 1886, and while its size and format has varied over the years, it continues to be published to this day. A number of its editors and reporters went on to pursue careers as journalists at major newspapers and news organizations. Here, assistant editor Karen Valenti lays out a page of the *Mirror* in preparation for printing.

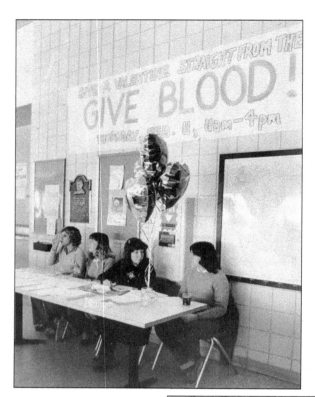

MY BLOODY VALENTINE, 1982. Student volunteers staff the reception table at a Valentine's Day–themed blood drive in Findlay Student Center on February 11, 1982. Clubs, fraternities, sororities, and even some academic classes have a long tradition of community service and volunteerism at Drury.

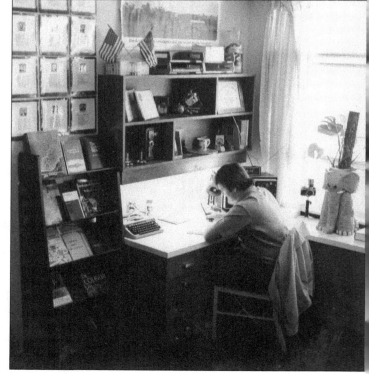

STUDENT STUDYING IN SUNDERLAND HALL. A student studies in his Sunderland Hall room about 1983. When it was opened in the spring of 1961, Sunderland was considered the best male dormitory on campus. But by the 1990s, its spartan rooms and common bathrooms were beginning to be considered obsolete, and it was razed in 2003 to make way for the new Sunderland Hall, a more modern "living-learning" community coeducational dorm.

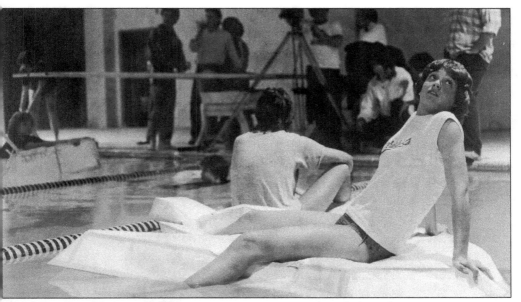

FRESHMAN ARCHITECTURE PROJECT, 1985. Drury University launched a rather tentative program in architectural studies in the fall of 1979 that was eventually transformed into a more robust accredited program in the mid-1980s. Here, freshman architecture students work on a paper boat project. Divided into teams, the students were required to design and build a boat made completely out of paper that would carry one student the length of the campus swimming pool and back.

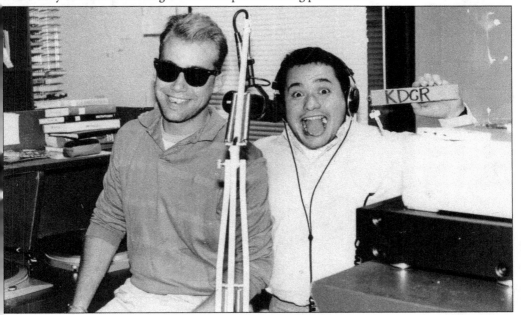

STUDENT DJS, KDCR, 1989. Drury's first radio station, KPAR, was started in December 1942 but ceased operation in April 1948. As KULR, it operated sporadically (and with a very limited range) from January 1968 until at least the mid-1970s, and it was later reconstituted as KDCR. In this photograph, KDCR DJs Brian Ferrell (left) and Jude Simmons mug for the camera in the studio. The legacy of KDCR lives on today through Drury University's current student-run FM radio station, KDRU.

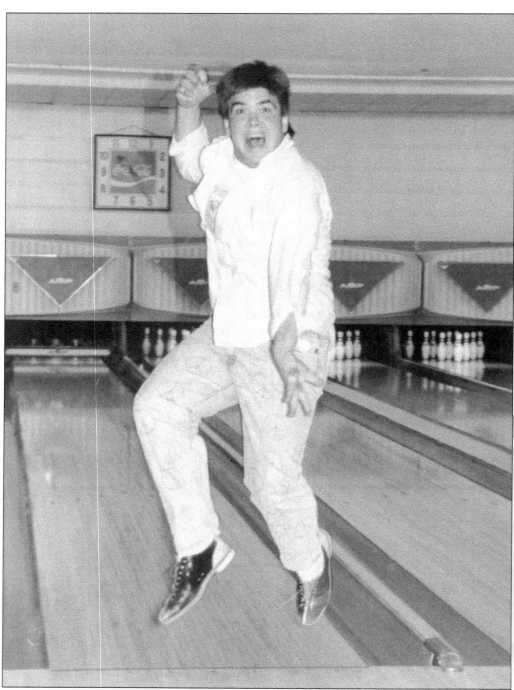

STRIKE! On a student bowling night off campus in the fall of 1990, junior Paul Epps celebrates a strike. Given the action and dramatic nature of the image, it is perhaps hardly surprising that when Epps graduated in 1992, one of his degrees was in theater. But like many Drury students with degrees in the humanities, Epps also took an additional degree, in his case, one in biology. He works today as a teacher of life sciences at Central High School, an International Baccalaureate school in Springfield, Missouri.

Four

SPORT

BASEBALL PETITION, 1884–1885. The first evidence of student athletics at Drury is this petition, signed by 31 students and addressed to President Morrison and the faculty, in which the signatories "respectfully request . . . the privilege of organizing a base-ball league." They assure the faculty that the league will not "interfere with our regular college work." The students also hope that they will occasionally be able to "play a game with some neighboring school."

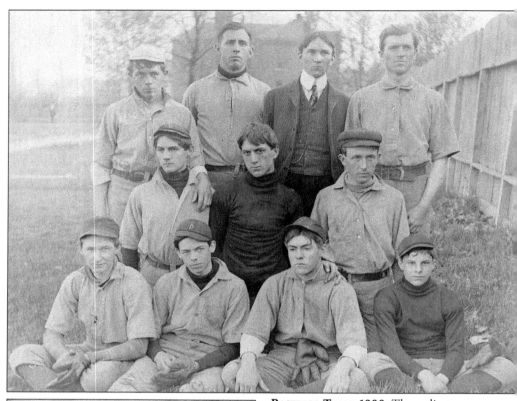

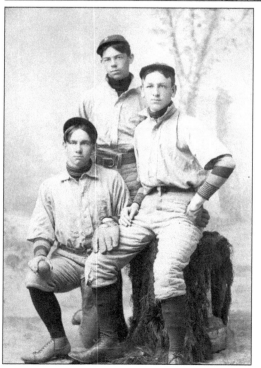

BASEBALL TEAM, 1900. The earliest score recorded for a Drury baseball team comes from 1895, when Drury lost to a team called the Springfield Shamrocks. Drury played a variety of teams: Central High, a YMCA team, teams raised in neighboring communities, and even a Frisco Railway team. In this 1900 image of the team, Warren White, later the sponsor of the Judge Warren White Scholarships, is in the middle row at left.

BASEBALL TRIO FROM VINITA, I.T., 1900. This studio portrait, from 1900, shows three members of the baseball team who were all from Vinita in the Indian Territory (Oklahoma). From left to right, they are Harry Bagby, Harry Smith, and Fred Ratcliff. On May 23 of the following year, Drury's baseball team would play its first intercollegiate game, losing to the University of Arkansas 5 to 7.

BASEBALL TEAM, 1904. This studio portrait of the baseball team and manager was taken for the 1904 *Sou'wester* yearbook. By this time, the team uniform had become decidedly standardized. The schedule of games, too, had become increasingly intercollegiate: there were matches against Texas University, Rolla School of Mines, and Springfield Normal (what would later become Missouri State University). Still on the schedule, though, were games against Central High School and local club teams.

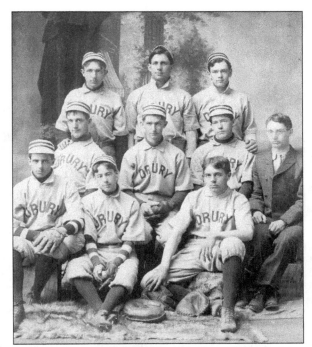

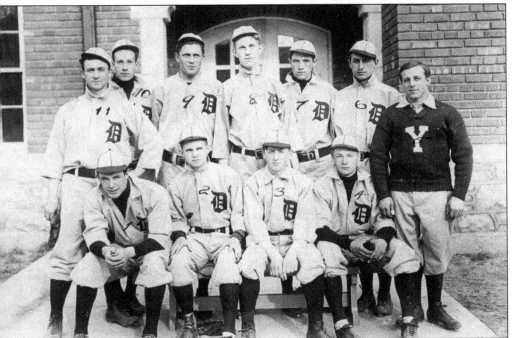

BASEBALL TEAM OUTSIDE THE FIELDHOUSE, 1910. Coach George Dole and the baseball team pose for a group portrait in 1910. Drury would win the state baseball championship in 1916 with a record of 10-3 for the season. But the sport was eclipsed by football and faded with the increasing popularity of basketball and track. Attempts in the 1920s and 1930s to revive an intercollegiate baseball team were unsuccessful.

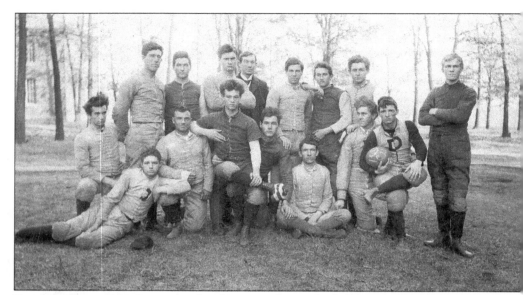

FOOTBALL TEAM, 1893. Drury played its first intercollegiate football game in 1891, losing 18-0 at home to Washington University. This group portrait, taken in 1893 on the campus grounds, is the earliest known image of a Drury football team. There is not yet a standard team uniform, and only three members appear to have a "D" logo on their chests. Some early teams even included faculty members.

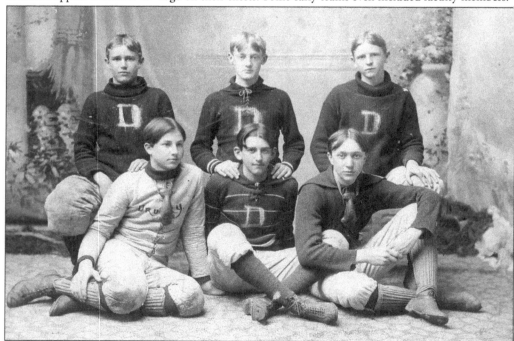

DRURY ACADEMY FOOTBALLERS, MID- TO LATE 1890s. Five football players pose for a studio portrait some time in the mid- to late 1890s. The relative youth of these boys indicates that they are students in the Drury Academy and not the college. Note that the letter "D" has been drawn with chalk onto the sweaters of four of the boys; the boy on the front row to the left appears to have had "Drury" inked onto his jersey.

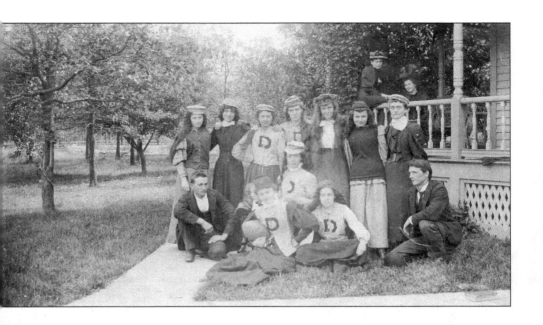

THE SENIOR ACADEMY GIRLS FOOTBALL SQUAD, 1894. These two group portraits, taken in May of 1894, show the "Senior Cad [Academy] Football Team." No record has been discovered of this team ever playing a game, and perhaps the photographs are nothing more than a bit of humor. On the back of one of the photographs, though, each young woman is identified with her requisite position. For example, Evelina Park is listed as "R. Tackle," and Berta Coombs as "R. ½ Back." (The men are listed as "Coach" and "Referee.") So perhaps this is an early permutation of powder-puff football. There are no other images in the collection showing a women's football team.

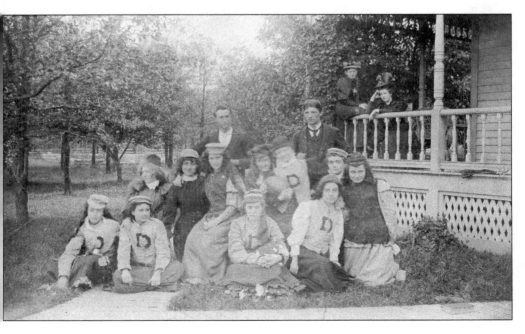

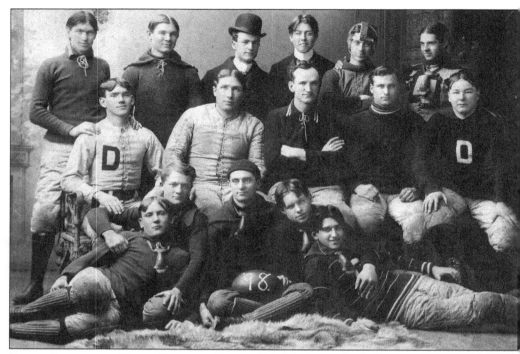

STUDIO PORTRAIT OF DRURY FOOTBALL TEAM, 1898. The Drury football team and manager pose for a studio group portrait in 1898. Several of the players have nose-guards on lanyards around their necks. And although helmets would not become standard football gear for some years to come, the player in the back row, second from right, appears to be wearing an early form of a helmet.

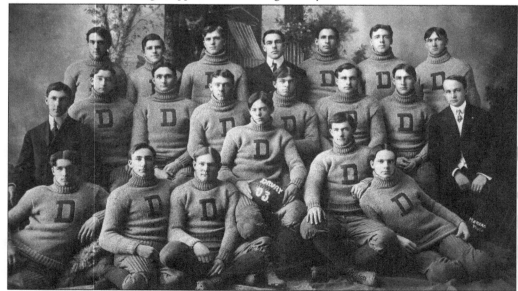

THE FOOTBALL TEAM, 1903. Another studio group portrait of the Drury football team, this one is from 1903. Initially, individual uniforms were anything but uniform: there was quite a bit of variation, and at least one source indicates that uniforms were often sewn by faculty wives. Here, the standardization of the lettered sweaters, pants, and cleats is noteworthy, as is the formal dress of the coaches and manager.

THE DEATH OF JOHN C. ALLEN. A persistent campus legend is that Drury's football program was canceled after a player was killed playing in a game. While that is not true, a Drury student, John Clark Allen, was indeed killed in a football game on November 11, 1899. Although Allen was a Drury student and football player, he was killed in St. Louis playing for the Christian Brothers College team in a game against a St. Louis University alumni team. He was only 24 years old. The obituary published in the *Mirror* the week after his death notes rather curiously that "John was not an ideal character," but hastens to add that "there are many points in his life which are well worth knowing." He is described as "faithful to every duty, industrious in his work," and the writer notes that "before going to a football game, he always brought down his Latin book and read his lesson to his teacher."

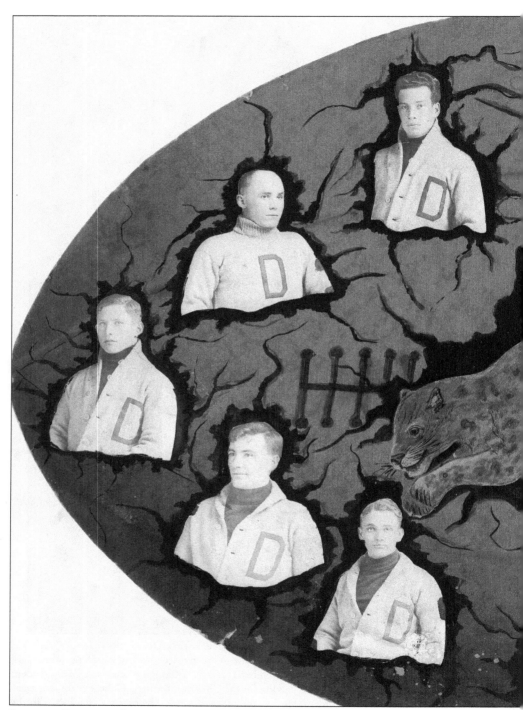

PANTHER FOOTBALL SQUAD, 1911-12. It is perhaps miraculous that this artifact, a pigskin-shaped composite of the Drury College football team that was used in the 1912 *Sou'wester*, the Drury yearbook, has survived. Constructed of cardboard, the background and the panther (which, with its spots, looks very leopard-like) are hand-painted; the photographs of the players are cut out and glued down to the

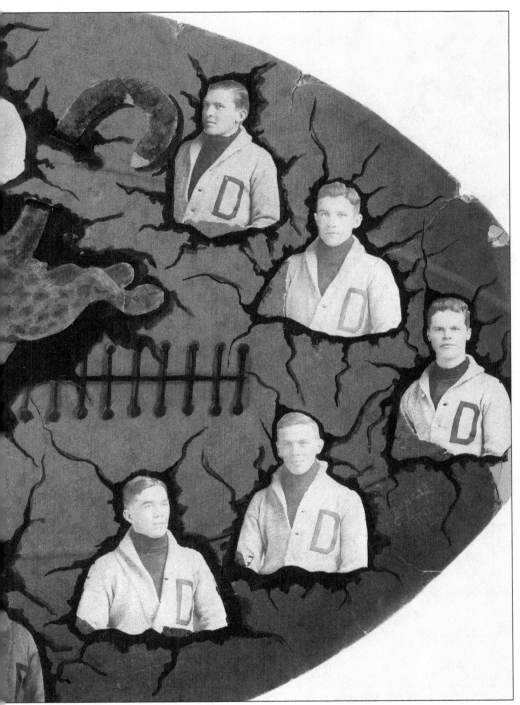

board. The players are, clockwise from the noon position, Henry Schierloh, Lowell Wasson, Frank Dillard, Clarence Marr, George Nixon, Charles Woody, Eugene Steinmetz, Robert Fyan, Guy Hawkins, William Foster, Waldo Jacobson, and team captain George Baldwin.

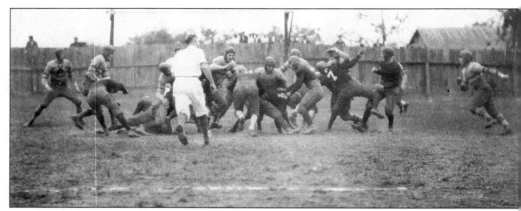

DRURY V. ARKANSAS, 1923. The Drury Panthers played the Arkansas Razorbacks at The Hill in Fayetteville on October 6, 1923. Arkansas was a member of the Southwest Conference, and this game was listed as a nonconference event. Not surprisingly, the contest was a serious mismatch, and Arkansas beat Drury 26-0. Note the spectators perched on the fence in the background.

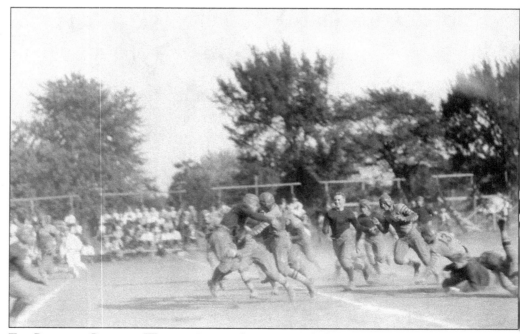

THE PANTHERS PLAY THE WILLIAM JEWELL CARDINALS, 1924. Another action shot, this was taken during a home game against the William Jewell Cardinals on October 18, 1924. Note that, by this date, most of the players are wearing leather helmets. In a *Mirror* article the day before the game, Drury coach Fred Walker refused to "make any very optimistic predictions" regarding the Panthers' performance. The Cardinals won the match handily, 20-0.

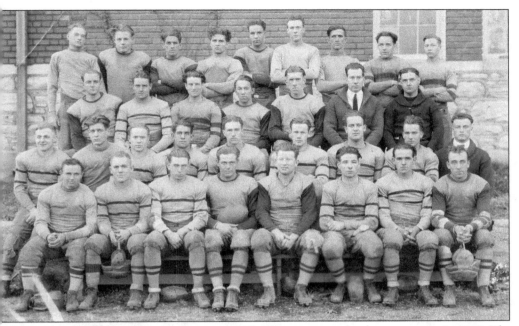

A TEAM PHOTOGRAPH BY THE GYMNASIUM, 1923. The team poses by the gymnasium in 1923. The uniforms are a bit varied, and some appear to be somewhat ragged or dirty, so this image might have been taken during a practice session. Sitting on the front row, fourth from the right, is Oscar Fryer, later a physics professor at Drury who would remain a fixture on campus until the late 1990s.

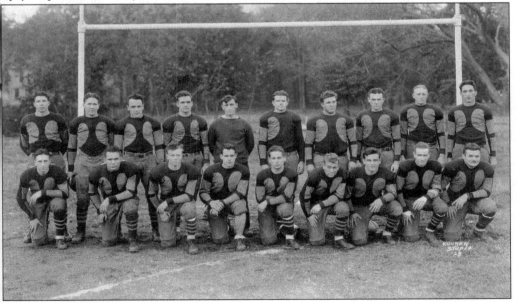

TWILIGHT: THE DRURY FOOTBALL TEAM, 1928. Coach A.L. Weiser stands with the Drury football team in 1928. The Depression made it increasingly difficult for the institution to maintain a football team, and in 1932, the board of trustees voted to end the program. Drury would play its last football game on November 18, 1932, losing 31-6 to Warrensburg Teachers College. An attempt to reintroduce football in 1947 proved unsuccessful.

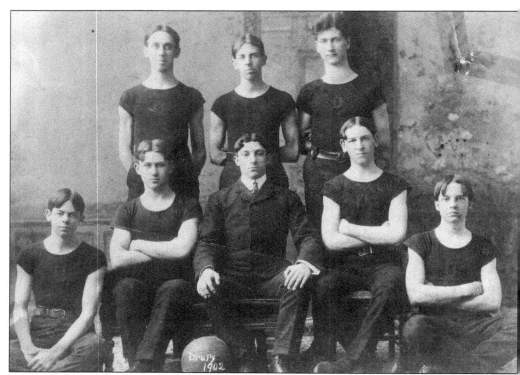

The First Drury Basketball Team, Fall of 1902. A Drury basketball team, formed in the fall of 1902, played its first games in the spring of 1903. Since the campus had no gymnasium at the time, games were played at the Springfield YMCA gym. The Drury team played two games each against Springfield High School, the Fourth District Normal School (now Missouri State University), and the YMCA team, winning and losing a game with each team.

Women's Basketball Team, Fall of 1902. This photograph from the 1903 *Sou'wester* is the earliest known of a women's basketball team at Drury College. The players are listed as Maude Hawkins, right forward; Minnie Outcalt, left forward; Vera Brereton, left guard; Clara Huntley, right guard and captain; Eva Smith, center; and Mary Kearney, touching center. The team played two games, winning against both the Rogers Academy (Arkansas) and Springfield High School.

WOMEN'S BASKETBALL TEAM, 1904. This studio portrait was taken for the *Sou'wester* yearbook of the 1904 women's basketball team. While no images from the period show a women's game in progress, one can assume that the team played in the rather heavy-looking dresses that they are wearing in this photograph. A photograph of a women's gym class taken around the same period shows the students exercising in long dresses.

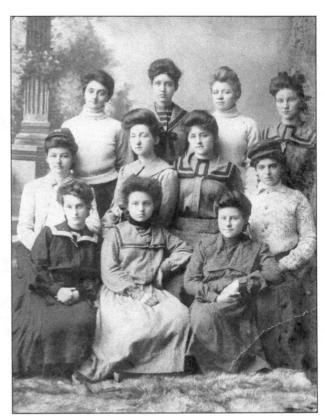

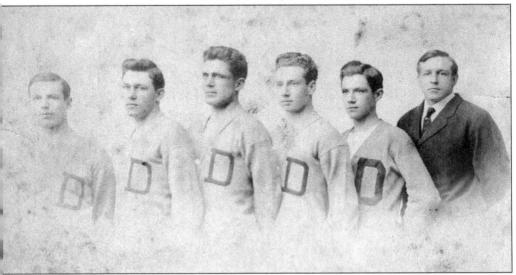

MEN'S BASKETBALL TEAM, 1910. This studio portrait of part of the Drury men's team was published in the 1910 *Sou'wester*. They are, from left to right, Richard Wagstaff, left forward; Allen Humphreys, left guard; Thurman McConnell, left forward and captain; George Baldwin, right guard; Frank Dillard, substitute; and coach George Dole. Not pictured are Ralph Wetzel, center, and Carl Moore and Karl Schweider, substitutes.

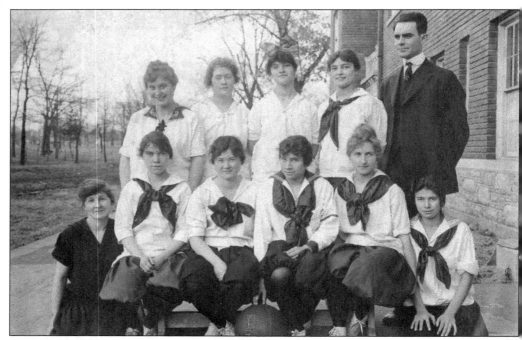

WOMEN'S BASKETBALL TEAM, 1915–1916. The women's basketball team poses in front of the gymnasium during the 1915–1916 school year. From left to right are (first row) Helen Watkinson, Vivian Snow, Josephine Pierce, Lillian Kump, Pearl Workman, and Maud Kump; (second row) Sylvia Leonard, Jean MacKesson, Gail Dye, Alta Appleby, and coach Eli Foster. The yearbook notes that the "Pantheresses" won four of the 10 games they played that season.

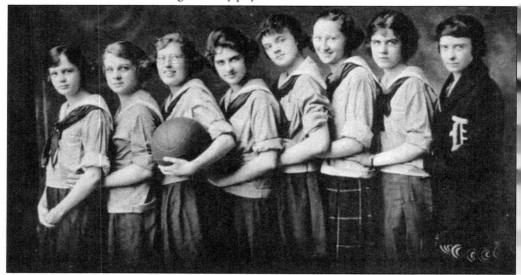

THE LAST OF THE FIRST: WOMEN'S BASKETBALL TEAM, 1921. The Drury women's basketball squad poses for its 1921 portrait. The Drury women won the state championship in the 1918–1919 season. But the yearbook entry for this photograph notes a lackluster season, adding that a "big obstacle which the team had to face was the absolute indifference on the part of the college." After 1921, there would be no women's intercollegiate basketball program at Drury for the next eight decades.

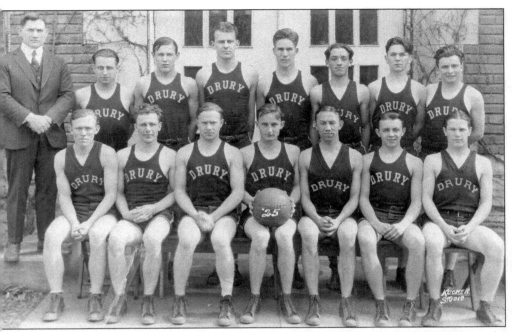

BASKETBALL TEAM POSES BY THE GYMNASIUM DOORS, 1925. The Drury basketball team poses by the gymnasium doors in 1925. The coach, Fred Walker, would be in place for the 1924–1925 and 1925–1926 seasons and would be replaced by coach E. Craig Davis, who would only hold the position for one season. In 1927, coach Albert L. Weiser would step into the role, remaining in the position for three decades.

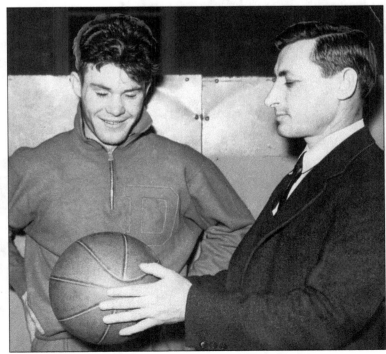

COACH WEISER AND "PEACHES" WESTOVER. Coach A.L. Weiser poses with Eugene "Peaches" Westover, probably about 1937 or 1938. Westover was an extraordinarily gifted athlete, and the Drury basketball team would win three consecutive Missouri College Athletic Union (MCAU) championships from 1936 to 1938. Westover graduated in 1938 with a degree in economics but was killed on December 12, 1944, while serving with the 3rd Armored Division in the Ardennes.

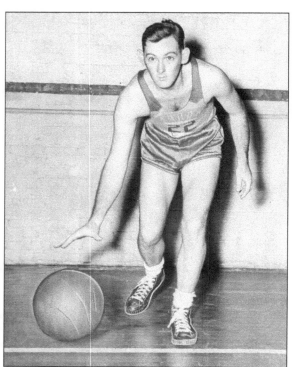

REBUILDING THE PROGRAM POSTWAR.
Jack Roberts, guard, strikes a pose for
the 1946 *Sou'wester* yearbook. Roberts
had played for the 1942–1943 season but
then entered the service during World
War II. Returning for the fall of 1945,
the *Sou'wester* noted that he was "quickly
getting his civilian legs loosened up,"
that he was "fast and shifty," and was
"already back to his pre-war form." He
would graduate in 1948 with a degree in
physical education.

**COACH WEISER GIVES A HALFTIME
TALK.** In the locker room at halftime,
coach Albert L. Weiser gives a strategy
talk to his team during the 1950–1951
season. With their sateen jackets, sateen
buckled shorts, and high-top athletic
shoes, the team is dressed at the height
of basketball fashion for the era. The
Panthers would finish the season at 13-7.

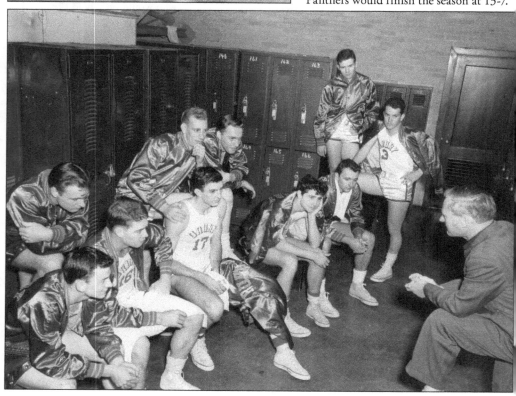

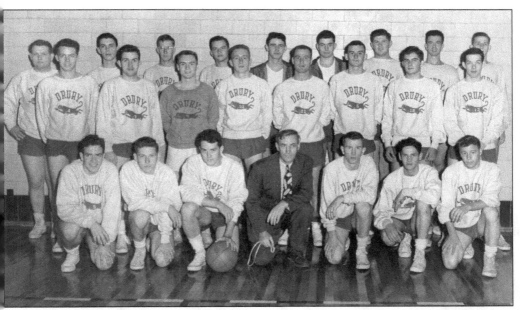

COACH WEISER AND A SUCCESSOR, 1951–1952. Coach Weiser and the Drury basketball team pose for their yearbook photograph for the 1951–1952 season. Weiser's tenure as basketball coach would stretch for three decades, from 1927–1928 to 1957–1958. In this photograph, in the middle row, third from right and wearing number 6, is sophomore Bill Harding, who would coach the Drury team from 1965–1966 to 1970–1971.

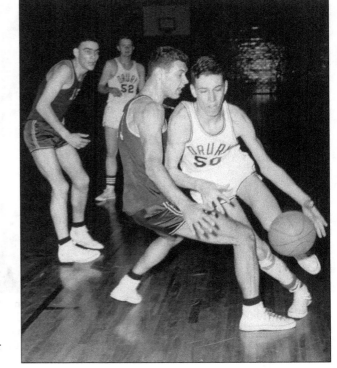

DRIVING IN FOR A SHOT, 1958. In a game during the 1958–1959 season, sophomore Dave Holman moves the ball against an opponent. In the background, wearing number 52, is senior Bob Kohly. This would be a lackluster year for the Panther squad, which would finish the season at 9 wins, 15 losses. Things would improve somewhat the following season after changes in the coaching staff.

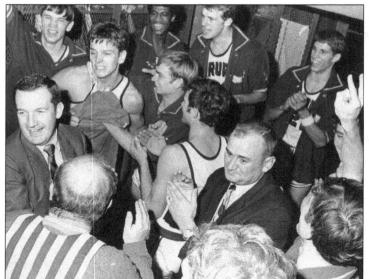

LOCKER ROOM VICTORY CELEBRATION. A raucous locker room celebration follows a Panther basketball victory during the 1969–1970 season. The Panthers would go to the National Association of Intercollegiate Athletics (NAIA) tournament and finish the season at 22-7. In this image, coach Bill Harding is roughly at center, and assistant coach Edsel Matthews is at the left. Both men would later serve as athletic directors for Drury.

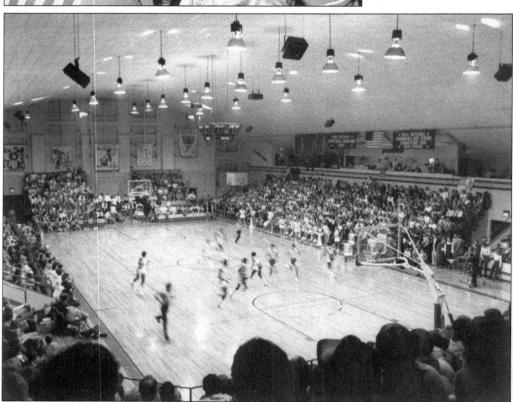

A GAME IN WEISER GYMNASIUM. The new fieldhouse, later named in honor of coach A.L. Weiser, was dedicated in 1948 and served as a venue for Drury home basketball games until 2010. Games in Weiser were intimate and noisy—spectators in the lower-level seats had to watch for stray balls that would occasionally rocket into the stands. This shot of a game, taken from the bleachers, probably dates from the mid- to late 1980s.

NAIA CHAMPIONSHIP GAME ACTION, 1979. The NAIA Championship Tournament was held in March 1979 at Kemper Arena in Kansas City. The Panthers would advance to the final game, defeating the Henderson State Reddies 60 to 54 for the championship. In this game shot, senior Lawrence Washington, in the last game of his college career, makes a leaping pass to a teammate. Washington would be awarded the Chuck Taylor MVP Award for his tournament play.

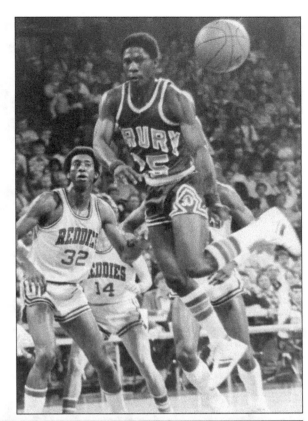

CELEBRATING THE NAIA CHAMPIONSHIP. Wreathed victoriously in the tournament nets, Lawrence "Flex" Washington (left) and Mike Carter celebrate Drury's NAIA championship on the floor of Kemper Arena. Other team members included James Bone, Nate Quinn, Kevin Weems, Curtis Hargus, Kent Russell, and Don Vincent. The team was coached by Jerry Kirksey and his assistant, Skip Shear.

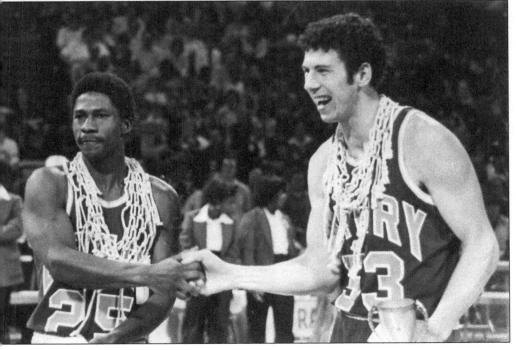

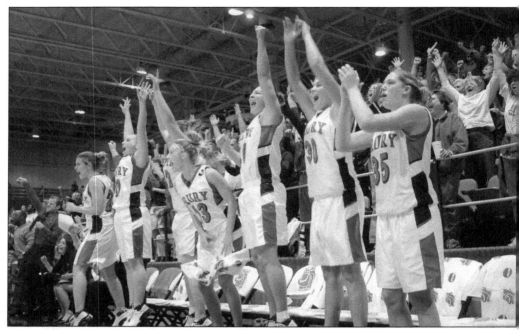

THE BENCH CELEBRATES A PLAY, 2004. A women's basketball program at Drury was reconstituted in 2000. Coached by Nyla Milleson, the team went to the final game in the 2004 NCAA Division II tournament, where it attained runner-up status. Here, the bench celebrates during a moment in the Elite Eight.

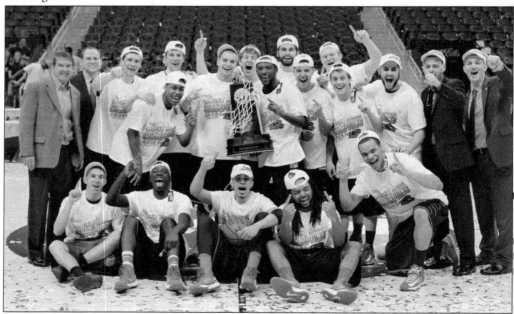

DRURY WINS THE NCAA II MEN'S BASKETBALL TOURNAMENT, 2013. In March of 2011, the Drury men's basketball team went all the way to the final game of the NCAA II tournament, barely squeaking by Metropolitan State University (St. Paul, Minnesota) in a nail-biter. Here, coach Steve Hesser and his team celebrate after winning the championship game by a single point.

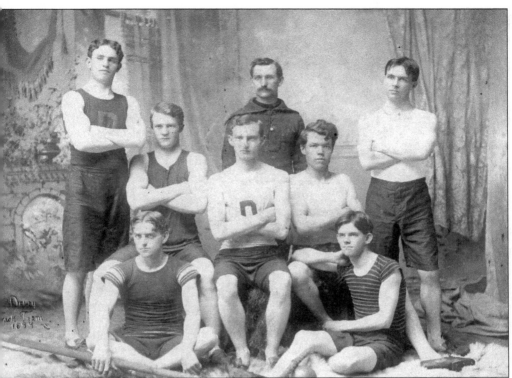

DRURY TRACK TEAM, 1899. Drury held its first intramural track and field day in 1893, and by the late 1890s, an intercollegiate team had been formed. Here, the track team poses for a studio shot in 1899. Among the track and field accoutrements included in the photograph are a shot put or hammer-throw ball, a discus, and what appears to be a javelin.

DRURY TRACK AND FIELD TEAM, 1903–1904. The track team poses for its *Sou'wester* group portrait for the 1903–1904 school year. Although the team appears to be an intercollegiate one, there is no record of competition against other schools for this year. Several school records are listed, though: John Cary held the school record for pole vault at eight feet, six inches; Archie Lowe's time in the 120-yard hurdles was 19.1 seconds.

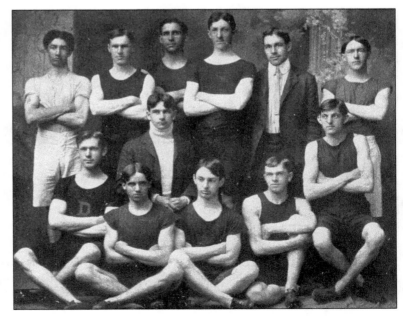

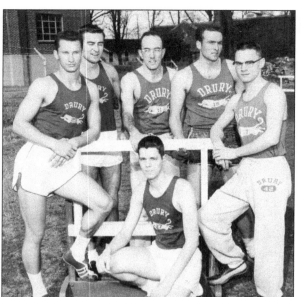

DRURY TRACK AND FIELD TEAM MEMBERS ON THE OLD CINDER TRACK. Members of the Drury track and field team pose on the old cinder track behind the South Gym during practice; the date is probably about 1956 or 1957. Kneeling is David Lange; standing from left to right are Bob Price, Mike Trower, Sid Hoskins, Charles Mason, and Clinton "Corky" Dederick. Each one of these athletes lettered in their event.

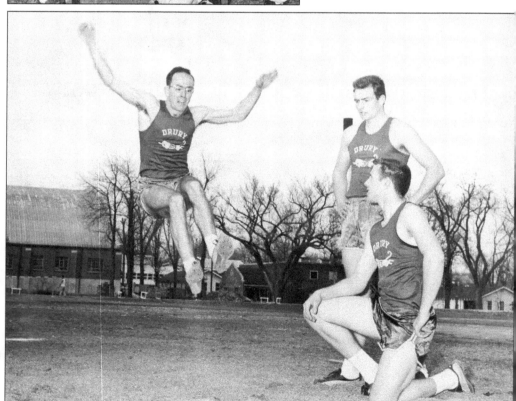

MAXIMUM EFFORT AT THE LONG JUMP. Sid Hoskins gives it his all and shows his game face while practicing the long jump about 1956. Charles Mason (standing) and Tom Kellogg, later a Drury trustee and benefactor, look on. Today, Drury's NCAA Division II teams include men's and women's track and field, cross country, and women's triathlon.

THE MCCULLAGH COTTAGE TENNIS CLUB, 1904. Members of the McCullagh Cottage Tennis Club pose for a studio group portrait in 1904. Interest in the sport blossomed at the turn of the century, and the campus added tennis courts about the same time. While the sport was played intramurally for many years, intercollegiate tennis competition is first mentioned in the 1930 *Sou'wester*.

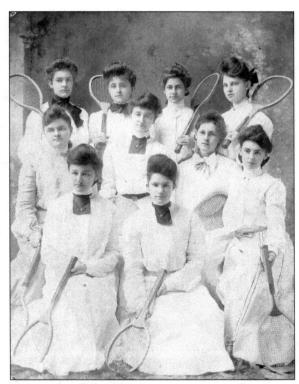

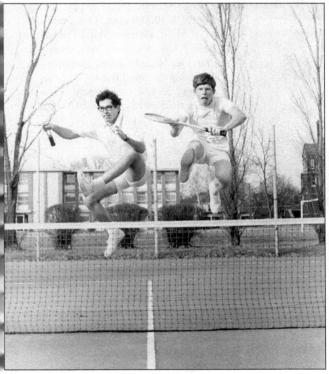

CLEARING THE NET, 1968. Tennis lettermen Keith Campbell, left, and Steve Meyercord clear the net in the fall of 1968. Drury's tennis team won consecutive MCAU league titles in 1951, 1952, and 1953. The vitality of the program varied over the years; the 1968–1969 season was described as a "rebuilding" year by coach Gerald Perry. The program was revitalized in the 1970s, placing in the NAIA tournament in 1973–1974 and the following year.

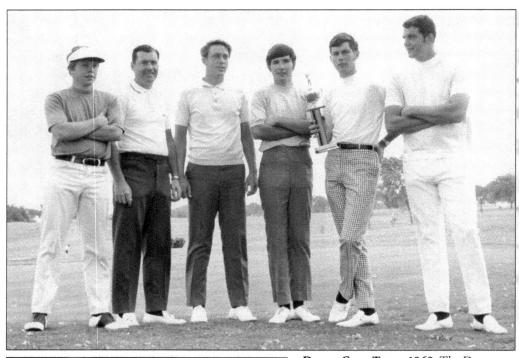

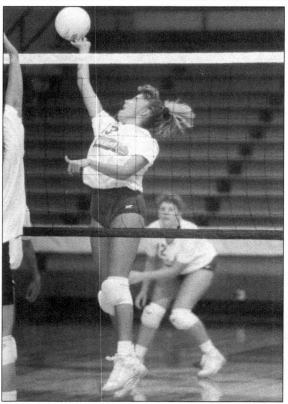

DRURY GOLF TEAM, 1969. The Drury golf team poses with the Missouri College Athletic Union trophy during the 1968–1969 season. They are, from left to right, Dennis "Skip" Talley, coach Larry Clark, Vic Cox, Steve Sheppard, Don Deeds, and George Thompson. The team captured the MCAU title during a 36-hole tournament held in Springfield on May 12 and 13, 1969.

VOLLEYBALL ACTION SHOT, 1990. Volleyball was played for many years as an intramural sport at Drury. The official history of Drury University, however, notes that volleyball "was slower to develop as a varsity sport." But after a fitful start, the program became established in the late 1970s. This game shot shows sophomore Julie Wells in action.

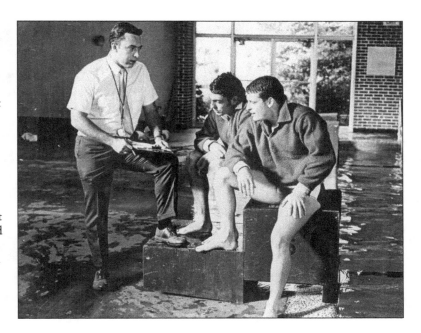

COACH JACK STECK AND DRURY SWIM TEAM CAPTAINS. Men's intercollegiate swimming was added as a team sport in 1965, and Jack Steck was named coach that same year. Steck would build a program that won its first MCAU championship in 1967 and won its first NAIA swimming and diving championship in 1981. Here, Coach Steck meets with Drury swim team cocaptains Bill Kerr (left) and Jon Witt.

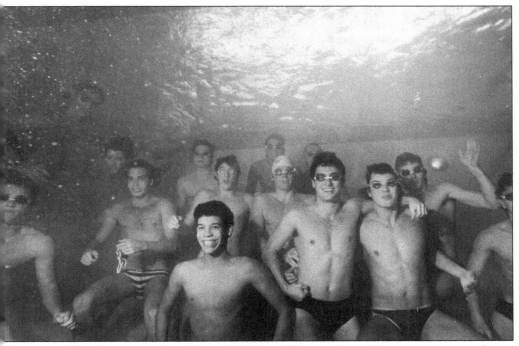

MEN'S SWIM TEAM UNDERWATER GROUP PORTRAIT. The Drury men's swim team poses for an underwater portrait during the 1986–1987 school year. While identifying the position of individuals is a bit difficult, among those present are Pete Hill, Paul Braswell, Machy Vicioso, Andy Lovan, Per Ericksson, Robbie Didriksen, Glen Brown, John Lambert, Trent Rinker, Peter Johannson, Jonas Westerholm, Brian Savage, Kent Nicholson, and David Hartsler.

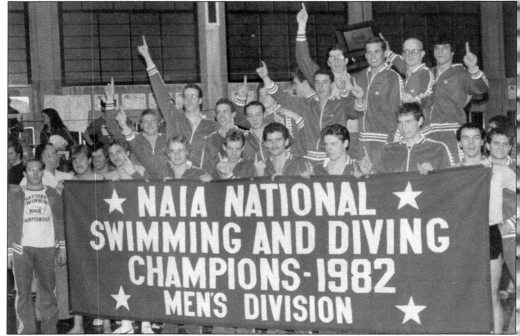

MEN'S NAIA CHAMPIONSHIP, 1982. The Drury men's swim team celebrates its second NAIA championship in a row in 1982. Coach Jack Steck stands to the bottom left looking back; Brian Reynolds, who would succeed Steck as coach in 1983, stands at top right with the championship plaque held behind him. Since the 1980–1981 season, the Drury men's swimming and diving team has secured over 20 national NAIA and NCAA Division II championships.

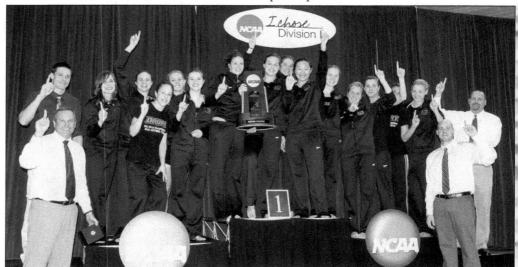

WOMEN'S NCAA DIVISION II CHAMPIONSHIP, 2011. The Drury women's swimming and diving team celebrates its eighth NCAA Division II national championship in 2011. Coach Brian Reynolds, who has coached the team since its inception in 1988, stands to the left. As with the men's program, the women's team has established a strong record, racking up over a dozen national championships, first in the NAIA and then in the NCAA Division II, since its 1991–1992 season.

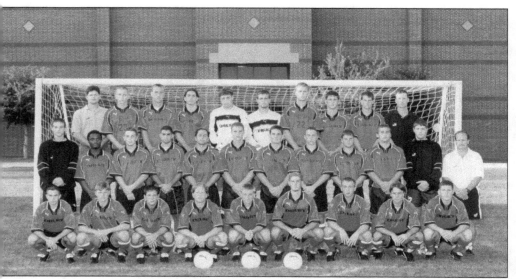

THE MEN'S SOCCER TEAM, 1998–1999. In 1990, Drury established its first intercollegiate programs in men's and women's soccer. (The programs were formed initially under the NAIA; Drury switched to the NCAA Division II for the 1994–1995 season.) The teams played their inaugural games in the fall of 1991. Here, members of the men's team pose with head coach John Senkosky for their 1998–1999 team photograph.

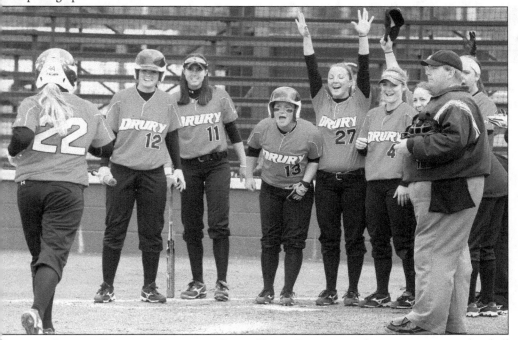

SOFTBALL PLAYERS CHEER AS A TEAMMATE COMES HOME. Despite several attempts to revive a baseball team, the sport remained dormant until 2006, when an NCAA Division II team was reconstituted. The following year, a softball team was formed. In addition, Drury currently has men's and women's NCAA II teams in basketball, cross-country, golf, soccer, swimming and diving, tennis, and track and field. There are also teams in volleyball and triathlon for women, as well as a men's wrestling squad.

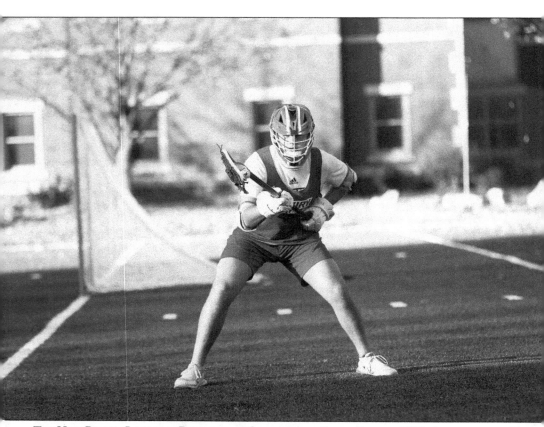

THE NEW BREED: LACROSSE PRACTICE ON SUNDERLAND FIELD, FALL OF 2022. In recent years, Drury has added a slate of non-NCAA club sport teams. There are now men's and women's teams in lacrosse and rugby, as well as teams in bass fishing, dance, e-sports, cheer, stunt, men's ice hockey, and shotgun sports. Here, Dax Salisbury of Tulsa, Oklahoma, strikes an aggressive pose during a lacrosse practice session on Sunderland Field, which has recently been upgraded from a sod field to one of artificial turf. Not surprisingly, some of the players on the men's lacrosse team are also hockey players, and several of them hail from Canada.

Five

DRAMATIS PERSONAE

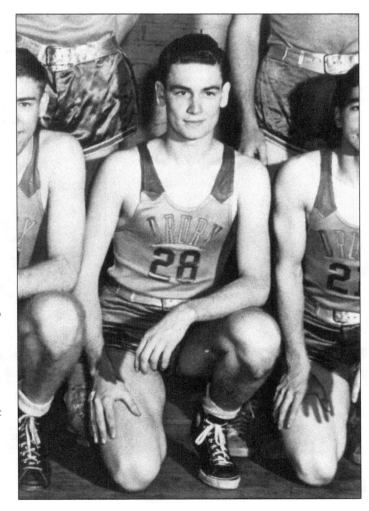

**"COME ON DOWN!":
BOB BARKER.** Drury's
most famous graduate is
undoubtedly Bob Barker, who
entered the college in 1942.
His studies were interrupted
by World War II, but after his
war service, he returned to
Drury and took a bachelor's
degree in economics, with
honors, in 1947. Barker is best
known for hosting *The Price
Is Right*, the longest-running
daytime television show in
American history. He is also
well known for his longtime
advocacy of animal rights.

FIRST ENROLLEES, FIRST GRADUATES: ANNA GRIGG (LEFT) AND EMMA GRIGG (BELOW). The first two enrollees at Drury, and the first two graduates, were sisters: Anna and Emma Grigg, who entered Drury on the first day of classes, September 25, 1873. They would graduate, in a class of five, on June 24, 1875 (there was no graduating class in 1874) with three other women: Jeannette Houghton, Addie McCluer, and Cora Perkins. In President Morrison's baccalaureate sermon, he declared that he did not "regret that ladies here lead the van in the long procession of cultivated students who will in the revolving years go forth from Drury College." He added, "Let it be a good omen for the great work which this school shall do for women in this fair land!"

"A.P.": ARTHUR PINCKNEY HALL.
When A.P. Hall entered Drury on the first day of classes, he did not know that it was the start of a 60-year relationship with the institution. After graduating from Drury, he earned his doctorate at Yale and then returned to teach classics. In his later years, he served as college dean. He was a popular and respected teacher: one student recalled that to read Cicero with A.P. was a "baptism."

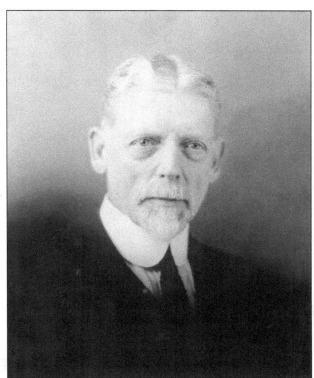

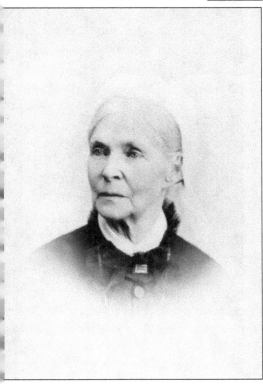

BENEFACTOR: VALERIA G. STONE. A generous early benefactor was Valeria Stone of Massachusetts. She initially gave $5,000 for the construction of a brick chapel; when she gifted an additional $20,000, it was deemed appropriate to build it of stone and name it in her honor. She would later provide funds to create one of the college's first endowed faculty chairs. Her gifts to Drury would eventually total $87,000, roughly the equivalent of $2.5 million today. (Courtesy of Wellesley College Archives.)

PETER JAMES HUDSON. Peter Hudson, a Choctaw Indian, came to the Drury Academy in 1879 from the Indian Territory, as Oklahoma was known at the time. He entered the college proper in 1882 and graduated in 1887. Hudson is best remembered as a preeminent historian of the Choctaws. A Federal Writers Project book described him as "a brilliant educator and writer, who used his talents to keep alive Choctaw history and tradition."

RACHEL CAROLINE EATON. Rachel Caroline Eaton, historian and educator, is believed to be the first Oklahoma Indian woman to have earned a doctorate. When she graduated from Drury in 1895, her commencement oration on capital punishment described the death penalty as "unnecessary . . . pernicious, [and] as a deterrent of crime . . . a miserable failure." A Cherokee, she later received her master of arts and doctor of philosophy degrees in history from the University of Chicago.

FRANK C. HUBBARD. Frank Hubbard (1887) single-handedly founded the *Drury Mirror*, the campus newspaper. After receiving approval from the administration, Hubbard published the first issue of the *Mirror* on September 24, 1886, and until June of 1887, when he handed the paper off to an editorial board of five students, was its sole employee. Hubbard went on to have a successful career as a journalist, newspaper publisher, politician, banker, and postmaster.

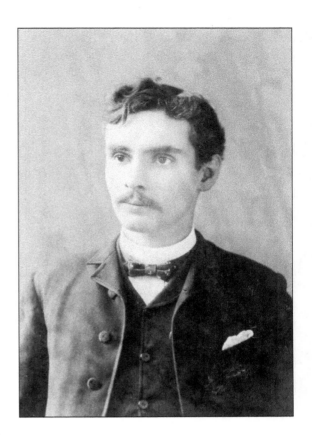

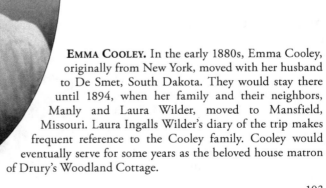

EMMA COOLEY. In the early 1880s, Emma Cooley, originally from New York, moved with her husband to De Smet, South Dakota. They would stay there until 1894, when her family and their neighbors, Manly and Laura Wilder, moved to Mansfield, Missouri. Laura Ingalls Wilder's diary of the trip makes frequent reference to the Cooley family. Cooley would eventually serve for some years as the beloved house matron of Drury's Woodland Cottage.

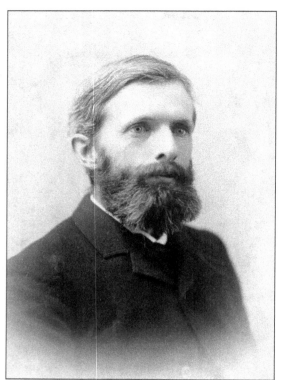

PROF. EDWARD M. SHEPARD. Dr. Edward M. Shepard arrived at Drury in 1878. Between then and his retirement 30 years later, he would serve as a faculty member in the natural sciences, the college librarian, acting president, and the curator of a museum of natural science that was eventually named in his honor. While he was a polymath of the sciences, he became a particularly well-respected authority on the geology of the Ozarks.

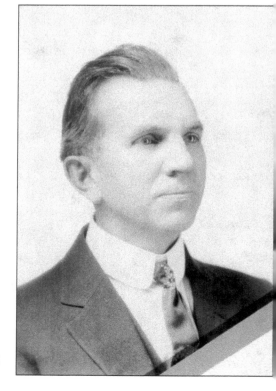

DR. BENJAMIN FRANKLIN FINKEL. Prof. B.F. Finkel started teaching mathematics and physics at Drury College in 1895 and would remain on the faculty until 1937. While one article described him as "a modest Missouri teacher," he was an important figure in American mathematics. In 1894, Finkel founded the *American Mathematical Monthly*, a publication still considered a leading journal in the field. He was also instrumental in founding the Mathematical Association of America.

CHARLOTTE "LOTTIE" VETTER, CLASS OF 1884. After graduating from Drury in 1884, Lottie Vetter planned to work as a medical missionary. But she and her husband, Luther Gulick, decided to stay in the States and in 1912 founded the Camp Fire Girls. She created the word "Wohelo" (*Wo*rk, *He*alth, and *Lo*ve) to illustrate the guiding ideas behind the Camp Fire movement. As a progressive educator, she was also an early proponent of sex education for children.

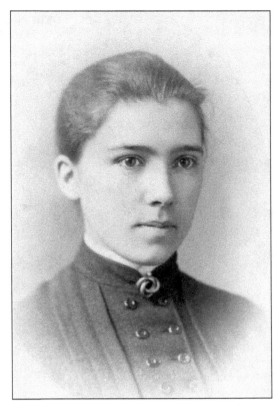

"GRAND BE THY DESTINY": HARRISON HALE. Prof. Harrison Hale joined the Drury faculty in 1902 and remained until the fall of 1918, when he went to the University of Arkansas. Although he was a chemistry professor, he is best remembered for writing the Drury "Alma Mater," which by 1910 was being sung at commencement and other college ceremonies. Originally referred to as the "Drury Hymn," it is set to the music of the Russian imperial anthem.

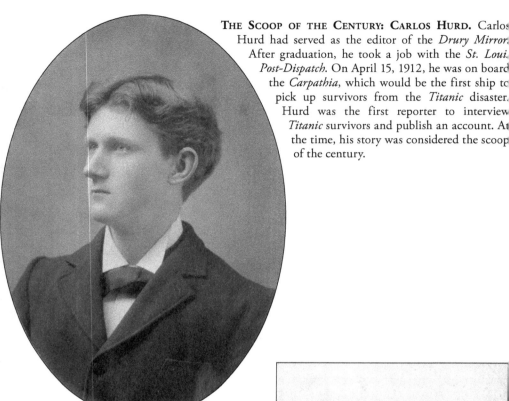

THE SCOOP OF THE CENTURY: CARLOS HURD. Carlos Hurd had served as the editor of the *Drury Mirror*. After graduation, he took a job with the *St. Louis Post-Dispatch*. On April 15, 1912, he was on board the *Carpathia*, which would be the first ship to pick up survivors from the *Titanic* disaster. Hurd was the first reporter to interview *Titanic* survivors and publish an account. At the time, his story was considered the scoop of the century.

DOROTHY VAN DYKE LEAKE, CLASS OF 1914. Dorothy Leake, PhD, was a pioneer environmentalist. She once argued that although government agencies had "permissible limits" for pollutants entering waterways, "the permissible limit is zero." In her retirement, she set up a data collection station on Crane Creek, one of the few Ozarks streams that was not afflicted by significant pollution, and for 30 years collected water-quality data to establish benchmark data sets for comparison to more polluted streams.

"Campus John," 1905 (Right) and "Campus Dan," 1913 (Below). In the early days on the Drury campus, there was no facilities unit, no maintenance office, no groundskeeping department, and no security service—there was a single man on campus who acted in these capacities. That man served as groundskeeper, general handyman, and night watchman. The archival record shows that two men in particular, John Hale, or "Campus John," and Dan Fedder, or "Campus Dan," were fixtures on campus for some years. Campus Dan seems to have been particularly popular with students, and there are frequent references to, and images of, him in the *Sou'wester* yearbook and the campus newspaper, the *Mirror.*

"PATER" AND "MATER" HOWLAND.
From 1893 to 1906, Clark and Mary Howland were fixtures on the Drury campus. "Pater," as he was affectionately called, was the principal of the Drury Academy; "Mater" was the housemother of Fairbanks Hall, which by this time was a boy's dormitory. As their nicknames suggest, they acted as parents to scores of academy boys. B.F. Finkel observed that the Howlands made Fairbanks "a real home for those . . . living there."

WILLIAM ADDISON CHALFANT: MUSICIAN AND OLYMPIAN. William Chalfant, born in 1854, graduated from the New England Conservatory of Music in 1879. He arrived at Drury in 1881, where he served as a professor of music and then as dean of Drury's conservatory. Drury's pipe organ is named in his honor. Chalfant also holds the distinction of being the only Drury faculty member who was an Olympic athlete: he competed in the 1904 Summer Olympics in the men's singles roque.

FREDERICK ALDEN HALL. Like his friend A.P. Hall (no relation), F.A. Hall was a graduate of Drury's class of 1878. After graduation, he would serve as the principal of the Drury Academy, then as a professor of Greek and dean of the college. In 1901, he left Drury to become Collier Professor of Greek at Washington University in St. Louis, where he was later named chancellor of the university.

PAUL ROULET. Paul Roulet was the second faculty member hired by Drury. A professor of both French and mathematics, he also acted as Drury's first historian, leaving an invaluable manuscript narrating the early history of the institution. He resigned his position in 1887, on the same day that President Morrison tendered his own resignation. While it is uncertain whether Roulet resigned due to Morrison's resignation, his manuscript reflects his fierce loyalty to Morrison.

FACULTY GROUP PORTRAIT, AFTER A CROQUET OR ROQUE MATCH. For some years, there was a croquet pitch located at the north end of the Drury campus. Drury's archival collection includes a series of photographs documenting a roque match, probably in the late 1800s, between faculty members. Here, the participants pose for a group portrait after the match. They are, from left to right, (sitting) William Chalfant, W.C. Calland, and B.F. Finkel; (standing) Pater Howland, unidentified, and A.P. Hall.

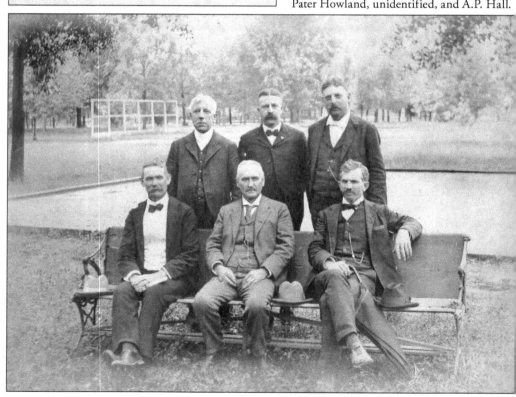

DEAN THOMAS STANLEY SKINNER. A graduate of the Oberlin Conservatory, Stanley Skinner's career at Drury spanned more than three and a half decades. Originally hired as director of Drury's Missouri Conservatory of Music, his position was elevated to a deanship in 1926. After his death in 1959, his grave remained unmarked until Drury alumni placed a stone in 1972. There are some who believe that his ghost haunts Clara Thompson Hall to this day.

ALBERT LUTHER WEISER. There is no figure more emblematic of athletics at Drury than A.L. Weiser (sometimes referred to as Al Weiser, "Bud" Weiser, or "The Grey Eagle"). Weiser coached at Drury from 1927 to 1958, making him the longest-serving coach in the history of the school. In basketball, his record over that period was 313-256, giving him a winning percentage of .550. Contemporaries described him as a model coach and gentleman.

PROF. L.E. MEADOR, ABOUT 1915. Lewis Elbern Meador taught history, political science, and economics at Drury for four decades. He is perhaps best remembered for the central role he played in drafting a revised constitution for Missouri, which was ratified by voters in 1945. As a historian, he was instrumental in seeing that Wilson's Creek became designated a national battlefield. Physics professor Oscar Fryer described Meador as one of the smartest people he had ever encountered.

LYMAN TURNER AND OTHERS, ABOUT 1954. Trustee Lyman Tuner, standing, looks on as Pres. James F. Findlay (left), board vice chairman Claud Rathbone, and Vice Pres. Carl Stillwell discuss campus planning with wooden models. In 1945, Turner would be the first trustee to call for the admission of African American students, a call that he would reiterate for a number of years. Drury would not act upon his repeated requests until 1964.

JAMES JESSE MAYES. After graduating from Drury, Jesse Mayes worked as a reporter for the *St. Louis Globe-Democrat* but resigned to serve in the Spanish-American War, commanding a company of the 7th US Volunteer Infantry, an African American unit. He would later take a command in the 24th US Infantry, also an African American unit. In World War I, he served on the staff of Gen. John Pershing. He attained the rank of colonel and died in 1924.

HOMER CASE. Homer Case graduated from Drury in 1915. When the United States entered World War I, he took a commission in the Army, serving in France. In World War II, he served both under Eisenhower in Europe and later under MacArthur in the South Pacific. He retired as a brigadier general, and at the time of his death in 1996, he was 101, the oldest living general in the United States.

SS *DRURY VICTORY.* The SS *Drury Victory* sits in drydock at Yard Two of the Permanente Metals Corporation in Richmond, California, prior to its launch on June 6, 1945. A number of World War II Victory cargo ships (successors to the Liberty cargo ships) were named in honor of American colleges and universities. The *Drury Victory* was christened by Veronica Forde, wife of Australian deputy prime minister Francis Michael Forde.

GEN. WILLIAM BEIDERLINDEN: "THE SAVIOR OF HEIDELBERG." After graduating from Drury in 1917, William Beiderlinden took an army commission and by 1943 was a brigadier general. He was given command of the artillery arm of the 44th Division, and by March 1945, troops under his command reached Heidelberg, a city of tremendous cultural importance. While he might have used his artillery to level the city, Beiderlinden instead carefully negotiated a surrender with his German counterparts, sparing Heidelberg.

ERNEST BREECH. Ernest R. Breech attended Drury from 1915 to 1917 before beginning a long and distinguished career in American industry. By 1929, he had become the assistant treasurer at General Motors, later moving on to North American Aviation and then being named president of Bendix Aviation. Breech became executive vice president of Ford Motors in 1946 and would serve as chairman of the board at Ford from 1955 to 1960.

DR. CURT STRUBE. Curt Strube came to Drury in 1969 and for many years was the director of the Breech School of Business. He was deeply respected on campus and by those in the local business community. Diagnosed with liver cancer in the mid-1990s, he continued to work even after chemotherapy left him almost totally deaf. When Strube died in 1997, local media described him as "the economics guru of the Ozarks."

Dr. Frank Clippinger. Frank W. Clippinger came to Drury in 1941 as the head of the English Department. In 1954, he was named dean of the college, and he served in that capacity until his retirement in 1965. Clippinger was an inveterate pipe-smoker, and some students recall seeing piles of matches on the ground in hidden areas outside of their dormitories—evidence that "Clipp" had been hiding nearby in an attempt to catch curfew-breakers.

Dean and Provost Steve Good. When Dr. Stephen Good was introduced to the faculty as dean in a meeting in 1983, one faculty member whispered to a counterpart next to him, "He's kinda short, isn't he?" A few minutes later, after hearing Good speak, the faculty member quipped, "He's getting taller!" Good was the first dean to be named provost at Drury, a title he received shortly before his death in February of 2004.

PROF. OSCAR FRYER. Oscar Fryer's association with Drury—as student, professor, and professor emeritus—spanned almost eight decades. Fryer entered Drury as a student in 1921 and graduated in 1925; after earning his doctorate, he taught physics from 1936 to 1967. He served for some years as an expert witness for Coca-Cola in lawsuits in which plaintiffs claimed that bottles had inexplicably exploded and injured them. Dr. Fryer would live to be 104.

PROF. WAYNE HOLMES. Wayne Holmes was for many years a professor of English literature at Drury. He was earthy and direct but kind and considerate. His specialty in Ozarks folklore was not merely an academic affectation: he and his wife, Mary Lou, raised cattle, sheep, goats, mules, and horses on a 630-acre Ozarks farm. A master of traditional pit barbecuing, Holmes occasionally used this skill to feed the entire faculty.

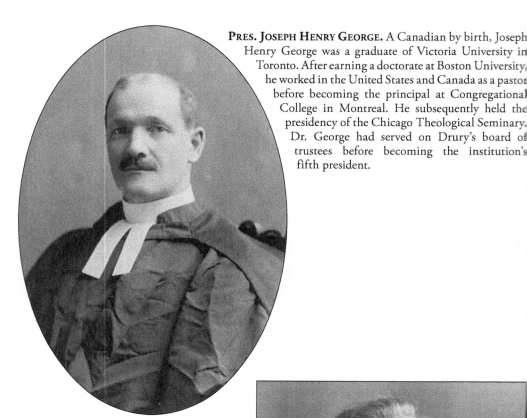

PRES. JOSEPH HENRY GEORGE. A Canadian by birth, Joseph Henry George was a graduate of Victoria University in Toronto. After earning a doctorate at Boston University, he worked in the United States and Canada as a pastor before becoming the principal at Congregational College in Montreal. He subsequently held the presidency of the Chicago Theological Seminary. Dr. George had served on Drury's board of trustees before becoming the institution's fifth president.

PRES. THOMAS NADAL. Dr. Thomas Nadal, the second-longest-serving president in Drury's history, led the institution during some of its most prosperous and challenging years. His presidency would see the addition of Wallace Hall, the Clara Thompson Hall of Music, and Harwood Library in the 1920s. In the 1930s, he would usher the institution through the Great Depression. Nadal was also the first president of the institution to fly on a commercial airliner.

PRES. JAMES F. FINDLAY. Dr. James Franklin Findlay was the longest-serving president in the history of Drury University. He took the reins in 1940 and retired at the end of the academic year in 1964. Findlay shepherded the institution through World War II and oversaw the transformational growth that the college experienced in the wake of that conflict.

JOHN E. MOORE JR. STRIDES ACROSS CAMPUS, 1986. When Dr. John Moore became president of Drury College in 1984, enrollment was down and finances were shaky. Under Moore's leadership, Drury was revitalized and experienced a period of building, strong enrollment growth, and academic transformation. After over 22 years at the helm, Moore retired in 2005, the third-longest-serving president in the history of the institution. Under his watch, Drury College became Drury University.

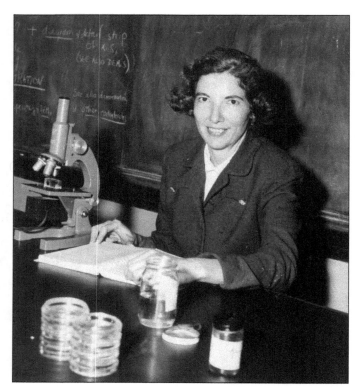

DR. LORA BOND. Dr. Lora Bond joined the Drury faculty in 1942 and taught for nearly 40 years. She was a biologist and the first woman to teach in the sciences at Drury. From 1948 to 1974, she was chair of the Biology Department. As Dean Stephen Good put it, Bond was a pioneer, one who was able to "not only survive in what was a man's world, but to become a leader."

RABINDRA ROY. Chemistry professor Rabindra Roy has earned numerous accolades in his discipline, but he also holds the singular distinction of being the longest-serving faculty member in Drury's history. His career at Drury spanned half a century, from 1966 to 2016. In 1995, he and his wife, education professor Protima Roy, founded the Hem Sheela Model School in Durgapur, India, a project that was to a great degree financed with their own earnings.

Earnest Brandenberg. After the long tenure of President Findlay, Earnest Brandenberg stepped into the Drury presidency in 1964. A thoughtful leader, he had to address an unfortunate racist incident on campus mere months into his presidency. His response was not just to rebuke the perpetrators but also to use the incident as a call to conscience for members of the entire community. Brandenberg was stricken with cancer and died in 1967, less than three years after his inauguration.

James L.H. Williams. The admission of African American students was suggested in 1873 by founder Samuel Drury but rejected by President Morrison. It would not be considered again until 1945, when trustee Lyman Turner raised the issue in a board meeting. The issue would continue to be discussed, with vague assurances made, until 1964, when Drury would finally admit its first African American student to the day school, James L.H. Williams, who graduated in 1967.

CHARLES H. BROWN. Charles Harrison "Charlie" Brown graduated from Drury in 1941. He worked in radio and television before running for the seat of Missouri's 7th Congressional District. Brown was elected in 1957 and held that seat for two terms. Relatively liberal politically, he lost to his fellow Drury alumnus Durward Hall in the 1960 election. He was the last Democrat to hold the seat for that district.

DURWARD "DOC" HALL. Dr. Durward Hall graduated from Drury in 1930 and took his medical degree in 1934. After a career as a physician in the US Army, he ran for Congress in 1960, winning the seat in Missouri's 7th Congressional District. He would hold that seat for six consecutive terms. A fiscal and social conservative, Hall was sometimes referred to as "Dr. No" due to his habit of voting against spending bills.

BETTY COLE DUKERT. Former Drury trustee Betty Cole Dukert attended Drury in the late 1940s before finishing her undergraduate studies at the University of Missouri's journalism school. After initially working as a "general flunky" in NBC's news department, Dukert became the associate editor for *Meet the Press* in 1956 and later became executive producer of that show, working with such personages as Yasir Arafat, Indira Gandhi, Fidel Castro, and Martin Luther King.

MARY JANE POOL. Mary Jane Pool graduated in 1946 and served on the Drury Board of Trustees for many years. Upon graduating, she joined the staff of *Vogue* magazine and later became executive editor of that publication. In 1968, she became editor-in-chief at *House and Garden*. She authored a number of books, including *The Gardens of Venice* and *The Gardens of Florence*. Drury's Pool Art Center is named in her honor.

123

ROBERT CUMMINGS. Charles Clarence Robert Orville Cummings attended Drury College his freshman year (1928–1929) before transferring to the Carnegie Institute of Technology and then the American Academy of Dramatic Arts. A prolific film and television star, he had roles in such films as *The Devil and Miss Jones* and *Dial M for Murder.* In 1954, he formed his own production company, and he starred in *The Bob Cummings Show* from 1955 to 1959.

DANNY DARK. Few people would know the name Daniel Croskery (class of 1961), but for years many heard his voice on a number of advertisements. Croskery, using the stage-name "Danny Dark," has been described in advertising circles as a "voice-over king." He was the voice of Clark Kent/Superman in Hanna-Barbera's *Super Friends* TV series from 1973 to 1985 but is probably best known as the voice that said "Sorry, Charlie" on StarKist Tuna commercials.

BILL VIRDON. Bill Virdon was recruited by Drury to play basketball in 1949 but left to play professional baseball. He would play major-league baseball as a centerfielder with the St. Louis Cardinals and the Pittsburgh Pirates and was named National League Rookie of the Year in 1955. Virdon would go on to coach the Pirates and the Houston Astros and would later manage the Pirates, Astros, New York Yankees, and Montreal Expos.

LAUREN HOLTKAMP. Lauren Holtkamp holds a bachelor of arts degree in business and an master of arts degree in communications from Drury, as well as a master of arts degree in divinity from Emory University. When women's basketball was resurrected at Drury in 2000, Holtkamp was on the team and played for four seasons. In 2014, she became a full-time NBA referee—the third woman to do so.

DABBS GREER, CLASS OF 1939. A native of Fairview, Missouri, Robert William "Dabbs" Greer was a well-known character actor whose career spanned over half a century. Greer had roles in such television staples as *The Andy Griffith Show*, *Gunsmoke*, *The Brady Bunch*, and *Picket Fences*. He also appeared in scores of feature films, including *Father's Little Dividend*, *The Invasion of the Body Snatchers*, and *Con Air*. He is probably best known to television audiences for his role as Reverend Alden in *Little House on the Prairie*. Greer is also remembered for his last film, *The Green Mile*, in which he portrayed Tom Hank's character, Paul Edgecomb, as an older man. Greer graduated with a degree in English, with departmental honors, since all drama and theater classes were at the time offered through that department. While at Drury, he participated in a number of campus productions.

BIBLIOGRAPHY

Asher, Harvey. *The Creation of a University: The Drury Story Continues, 1977–2004.* Bolivar, MO: From the Scholars Desk, 2007.

Clippinger, Frank W., with Lisa Cooper. *The Drury Story.* Springfield, MO: Drury College, 1982.

Roulet, Paul. "History of Drury College at Springfield, Greene County, Missouri. With a Sketch of the Early Educational Efforts by the Settlers of South West Missouri, Before the War," n.d. Unpublished typewritten manuscript. Drury University Archives.

DISCOVER THOUSANDS OF LOCAL HISTORY BOOKS FEATURING MILLIONS OF VINTAGE IMAGES

Arcadia Publishing, the leading local history publisher in the United States, is committed to making history accessible and meaningful through publishing books that celebrate and preserve the heritage of America's people and places.

Find more books like this at
www.arcadiapublishing.com

Search for your hometown history, your old stomping grounds, and even your favorite sports team.

Printed in the USA
CPSIA information can be obtained
at www.ICGtesting.com
LVHW011259250923
759185LV00007B/581